SHEFFIELD FROM THE AIR

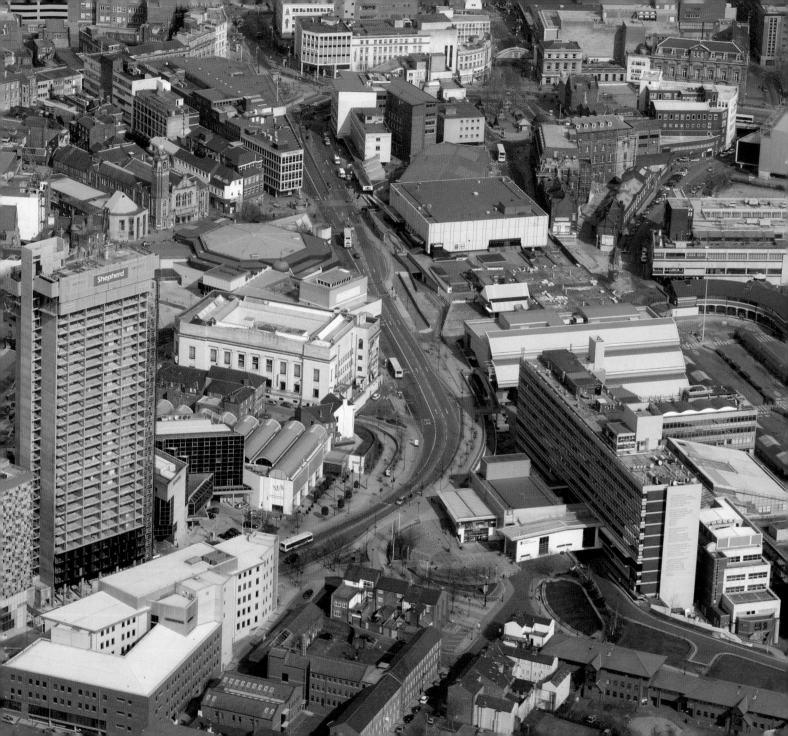

Ian Bracegirdle

SHEFFIELD FROM THE AIR

DB
PUBLISHING

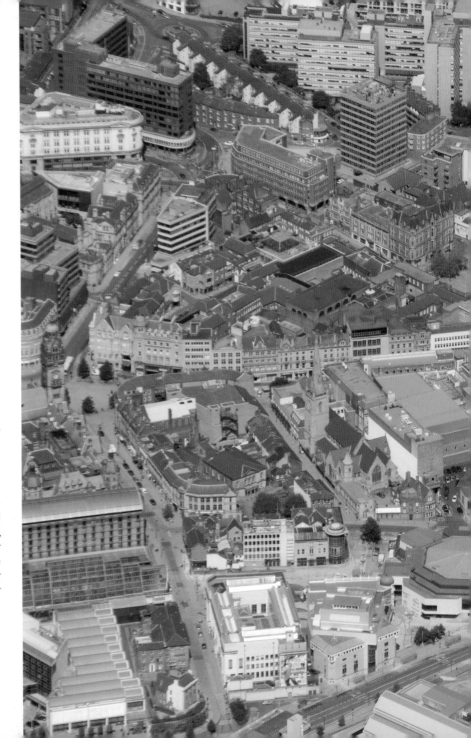

Acknowledgements

Pilot and friend Richard Napper
Thanks also to Tony Hather and
Maurice Housley
My wife Suzanne for help and
encouragement during this project
All at Derby Books
Citizens of Sheffield

First published in Great Britain in 2010 by The Derby Books Publishing Company Limited, 3 The Parker Centre, Derby, DE21 4SZ.

ISBN 978-1-85983-730-6
Printed and bound by Progress Press, Malta.

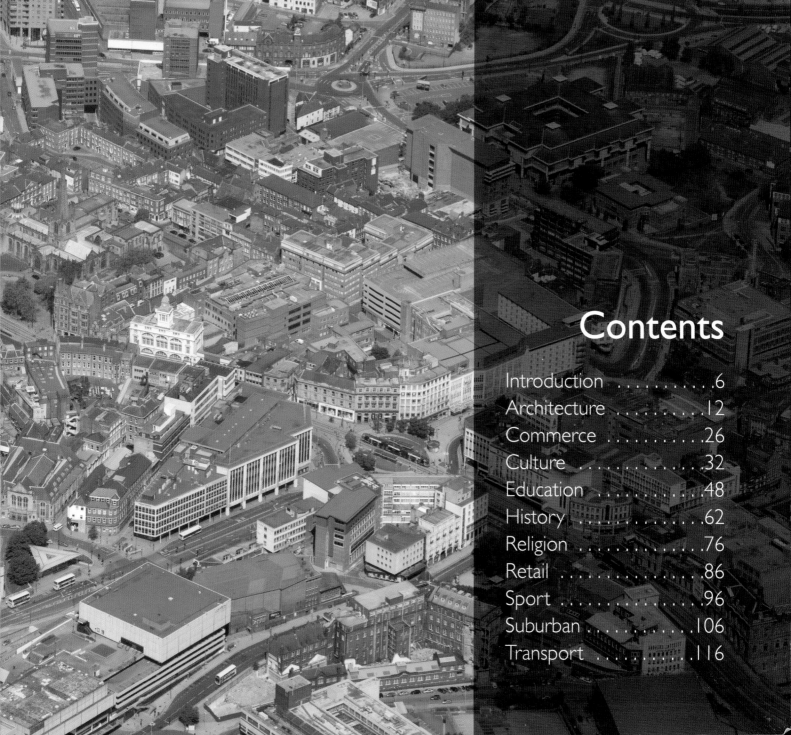

Contents

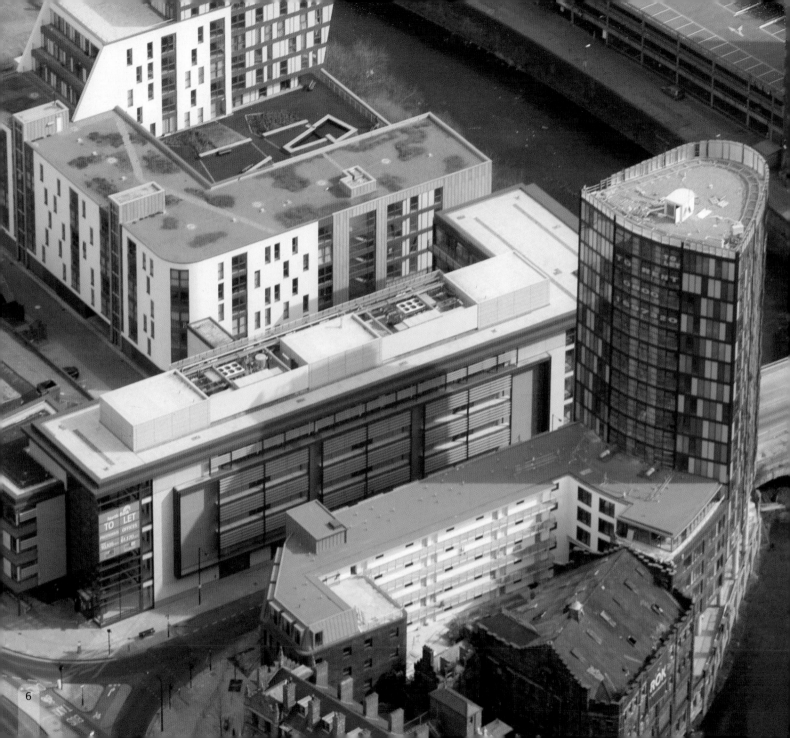

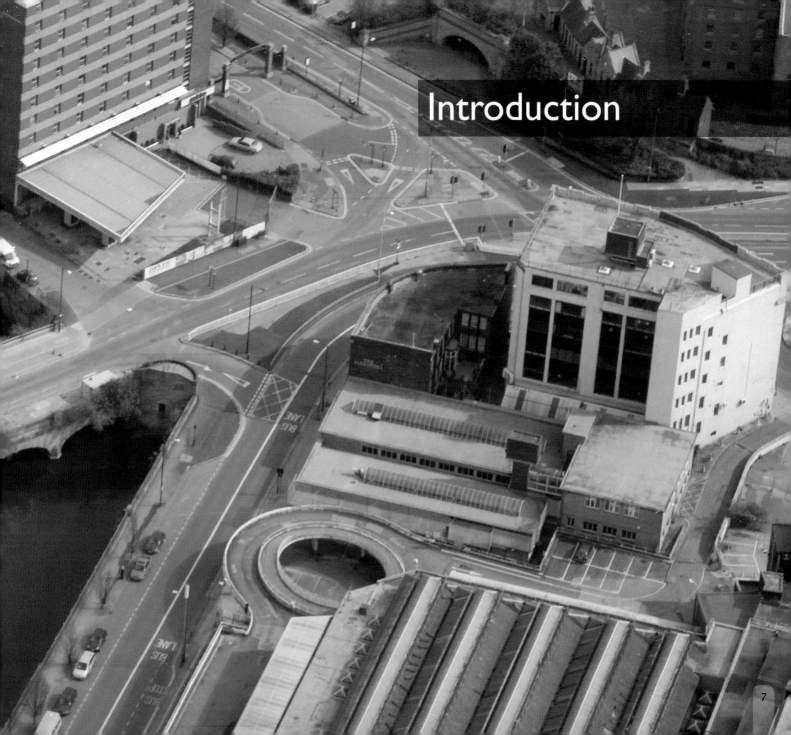

Introduction

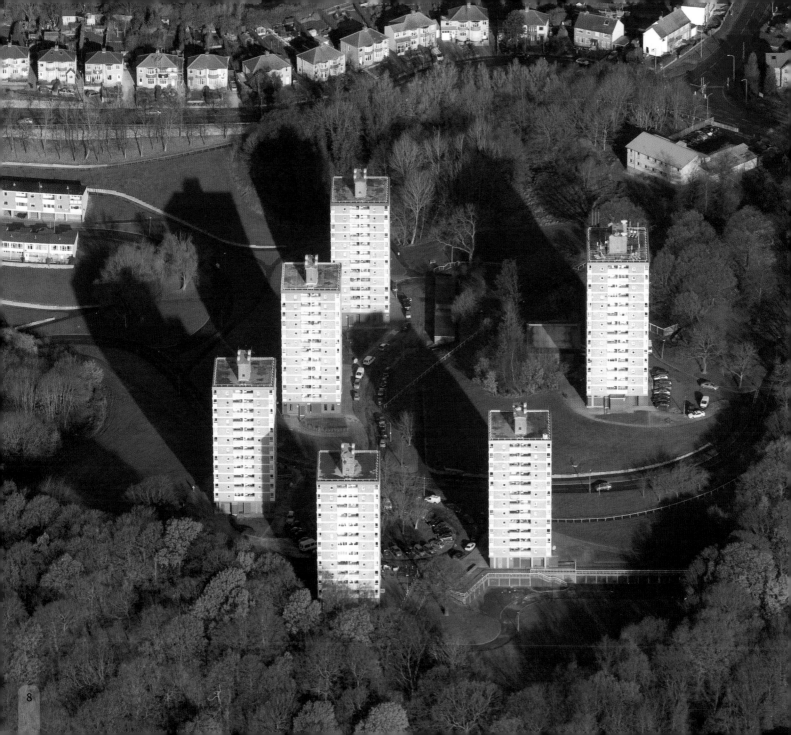

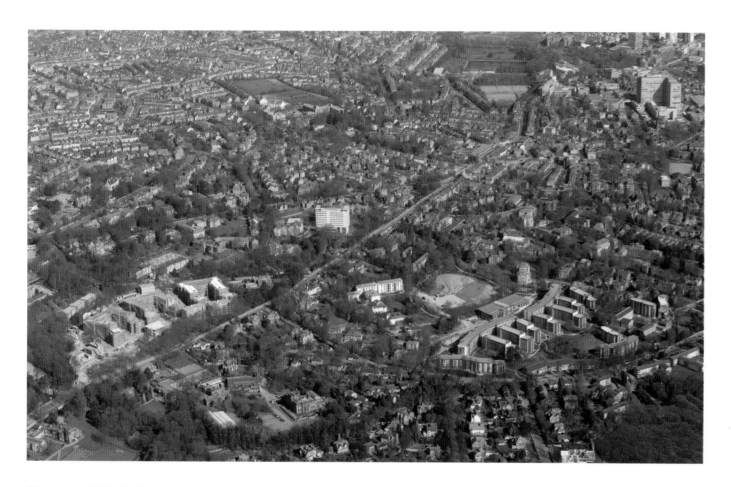

The city of Sheffield is known and respected throughout the world for many different reasons. Once the steel producing capital of the UK, if not the world, it became known as Steel City. Now, with a multi-cultural society of over 513,000 inhabitants, Sheffield has become one of the country's leading educational facilities with over 40,000 full-time students studying in the city. This, combined with Sheffield's excellent business, retail and sporting facilities, has created a modern, vibrant city in which to learn, work and live.

Sheffield from the Air looks at many of the city's landmark buildings and sights, as well as giving a flavour of what life is like for the people who live there.

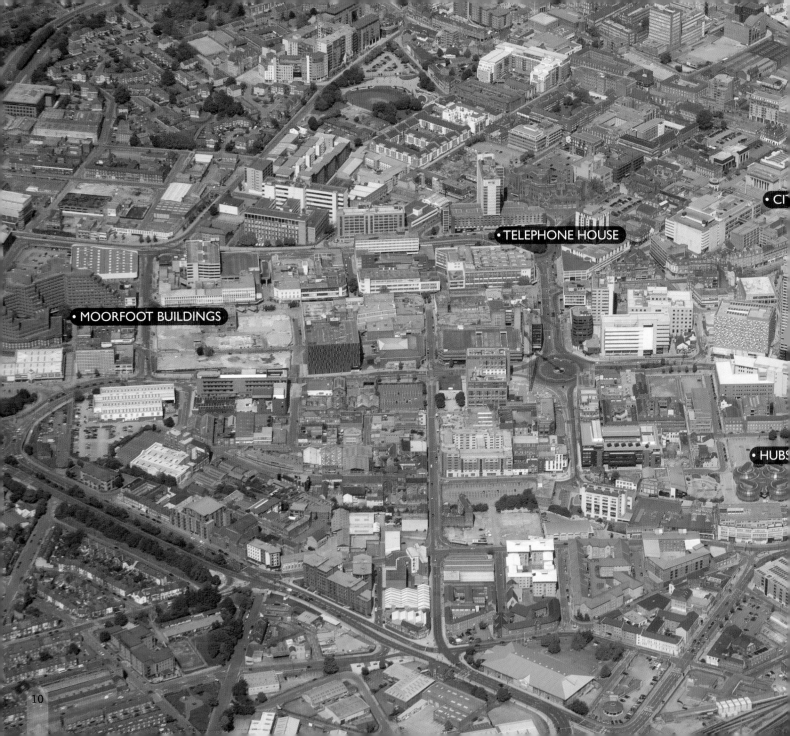

• MOORFOOT BUILDINGS

• TELEPHONE HOUSE

• CI

• HUBS

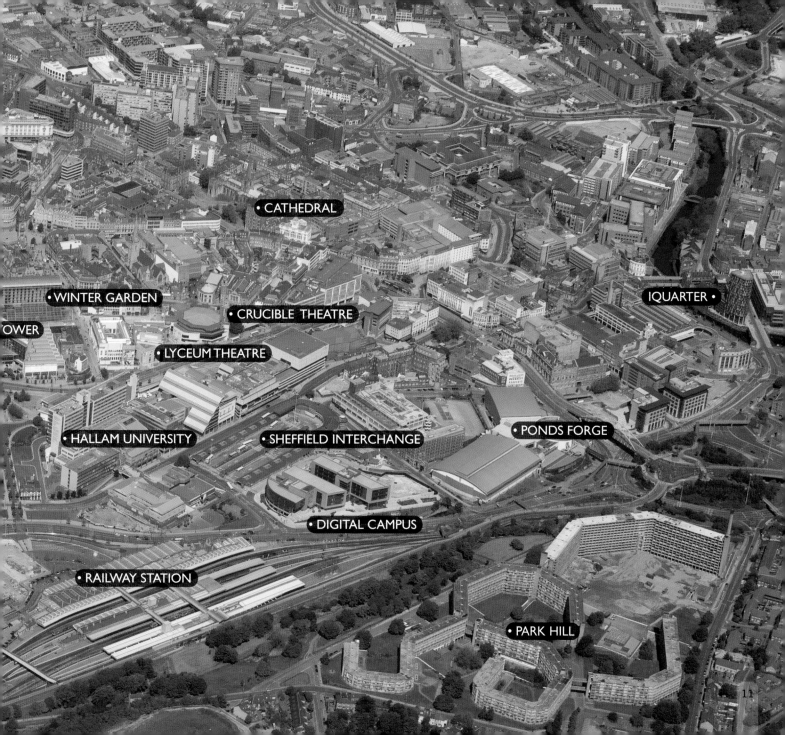

• CATHEDRAL

• WINTER GARDEN

OWER

• CRUCIBLE THEATRE

IQUARTER •

• LYCEUM THEATRE

• HALLAM UNIVERSITY

• SHEFFIELD INTERCHANGE

• PONDS FORGE

• DIGITAL CAMPUS

• RAILWAY STATION

• PARK HILL

11

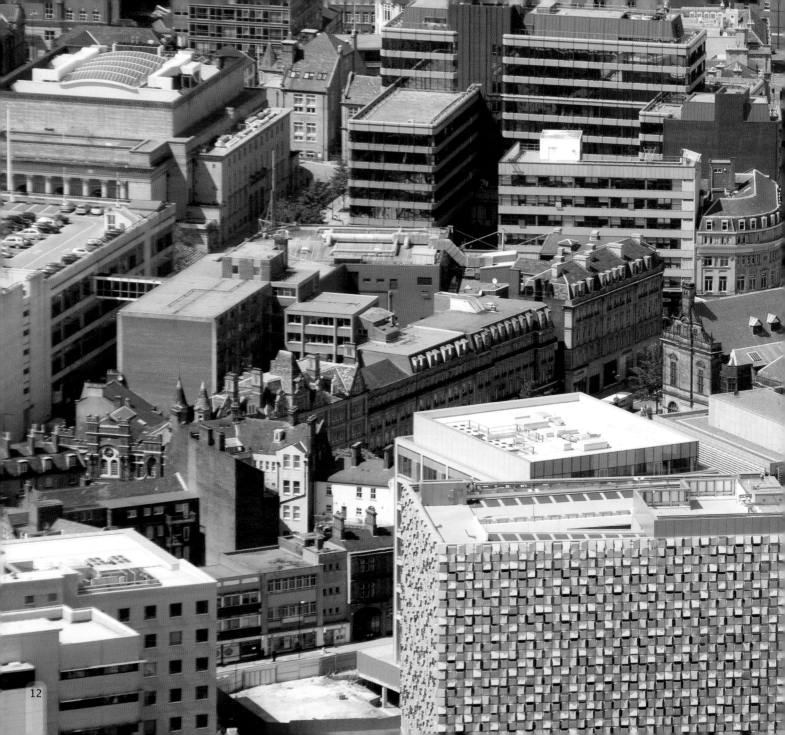

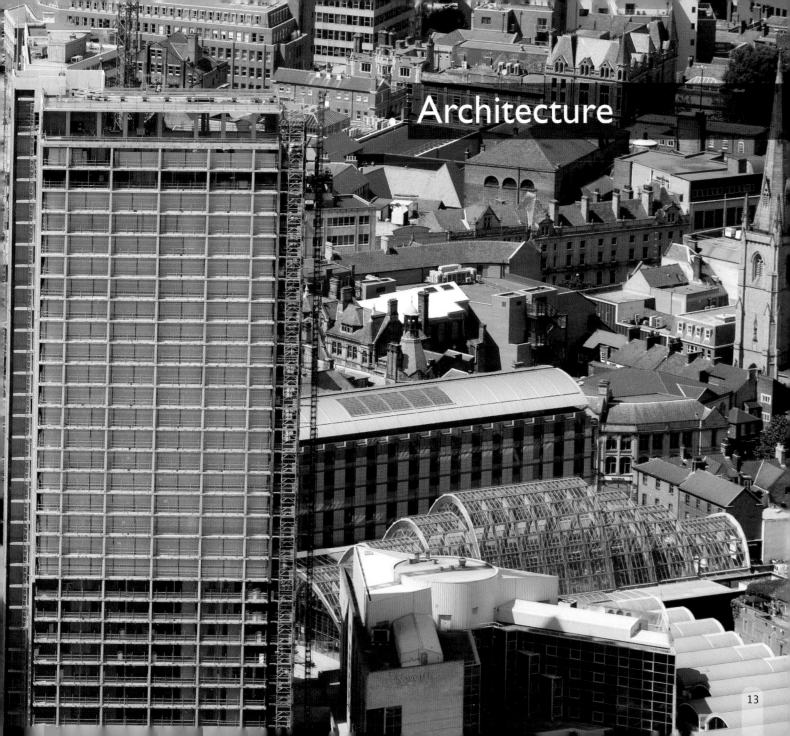

Architecture

Previous page: St Paul's Tower and Charles Street car park.

Left: The Arts Tower on Western Bank is the tallest university building in the UK.

Opposite and below: Lying to the south-west of the city centre is the **Velocity Tower**. Construction began in 2007 on the 22-storey building. The first of the 160 luxury apartments was completed in 2009. Planning permission has now been obtained to extend this to 31 storeys and an additional 80 apartments.

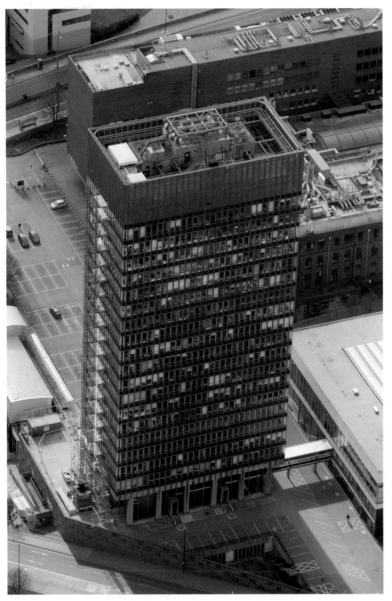

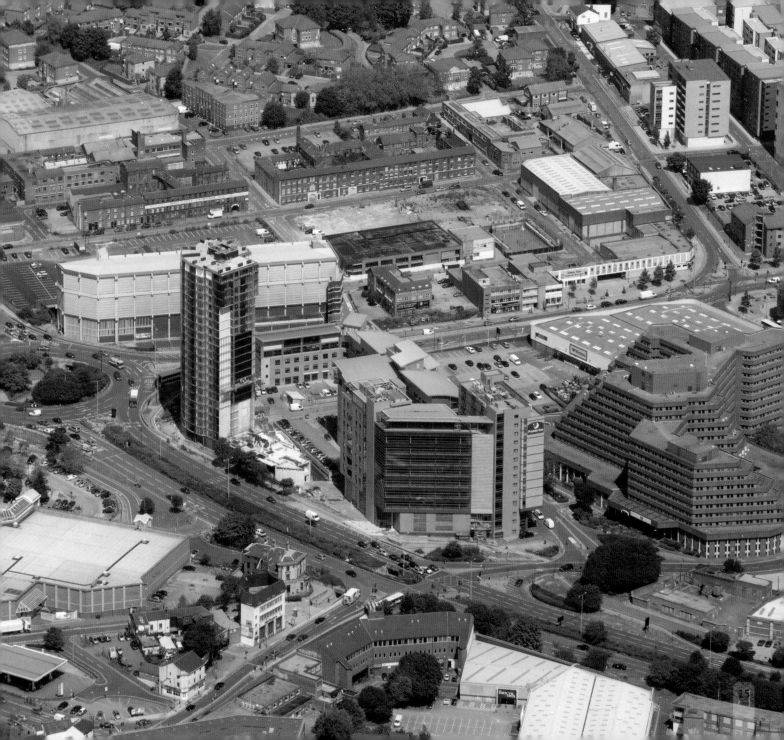

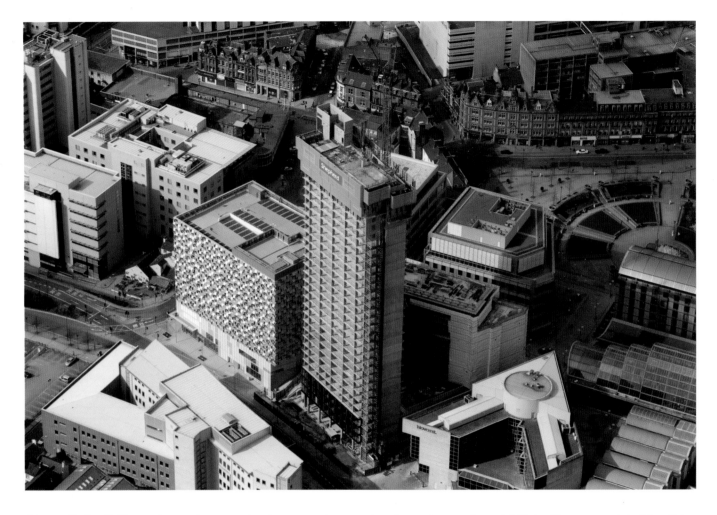

Above: St Paul's Tower is a major new development close to the city centre on Arundel Gate. Once completed it will be a 32-storey tower, the bottom of which will be shops while the rest of the block will be private apartments.

Opposite: Charles Street car park has aroused mixed feelings from the people of Sheffield. Some love it and some hate it, but one thing's for sure, the nickname Cheese Grater seems to have stuck.

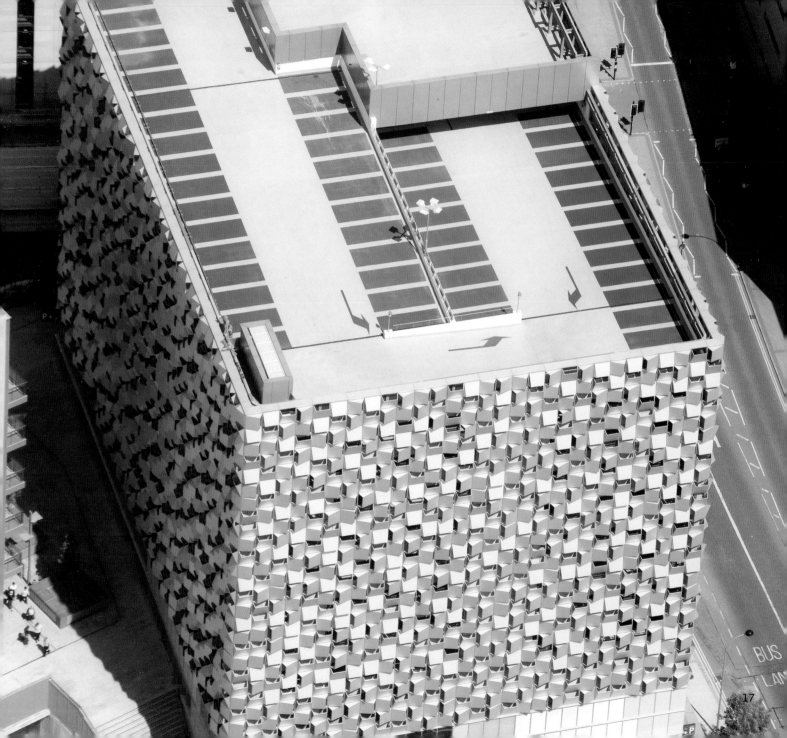

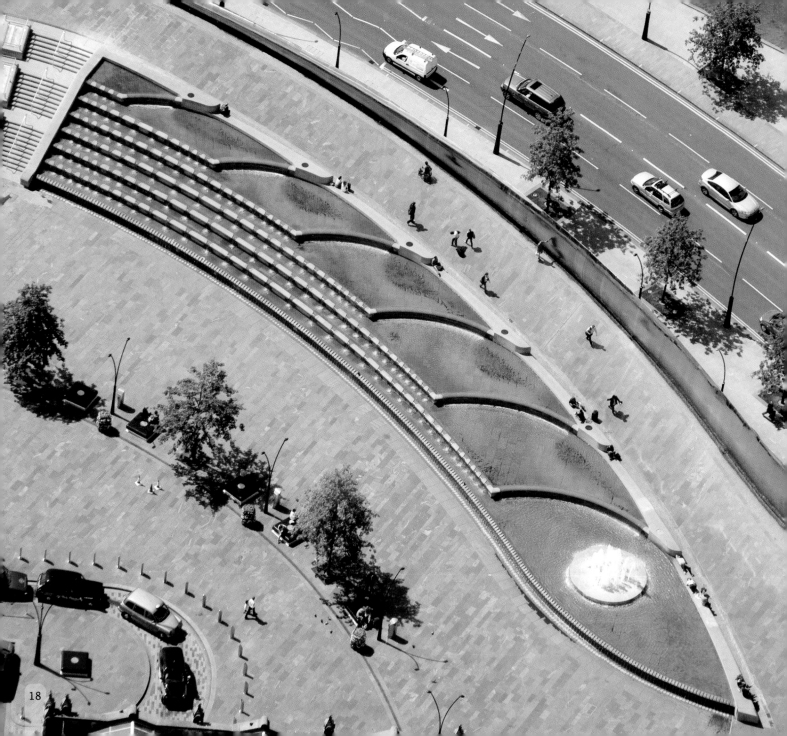

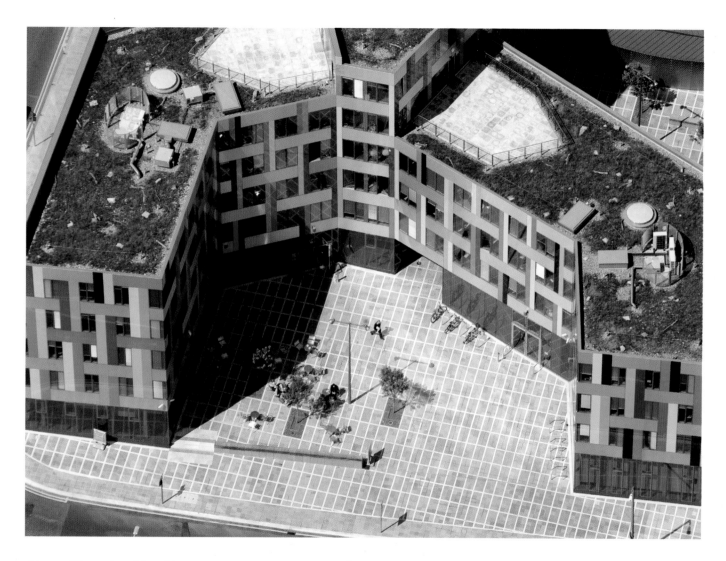

Above: The colourful architecture and biodiverse roof of **The University of Sheffield's Jessop West** site.

Opposite: Seen here are the water features in **Sheaf Square** next to the railway station.

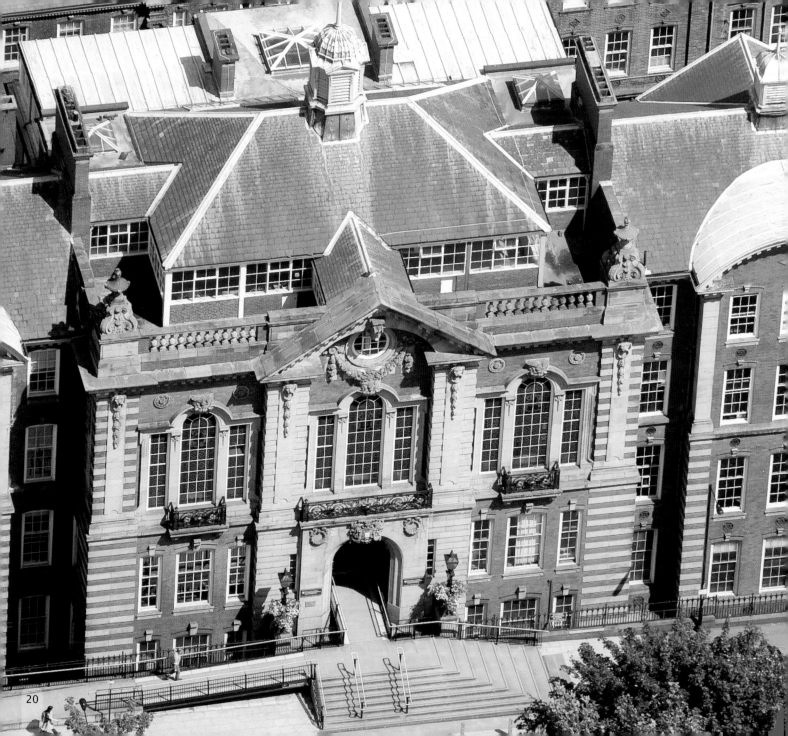

Opposite: The ornate façade of the **University of Sheffield Mappin Building**.

Right: There are a number of Grade II-listed buildings on the **Victoria Quays** site, including the original Terminal Warehouse, the Straddle Warehouse and a curved terrace of coal merchants' offices.

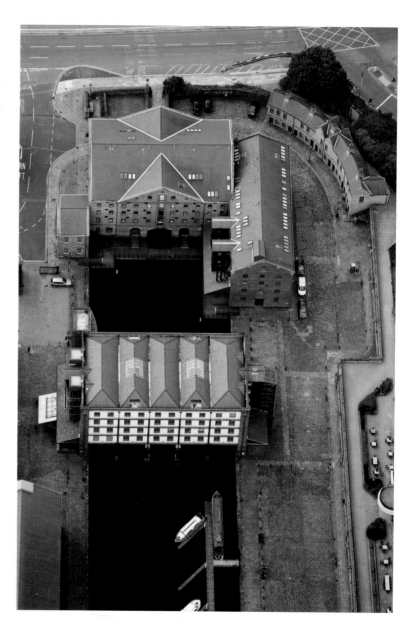

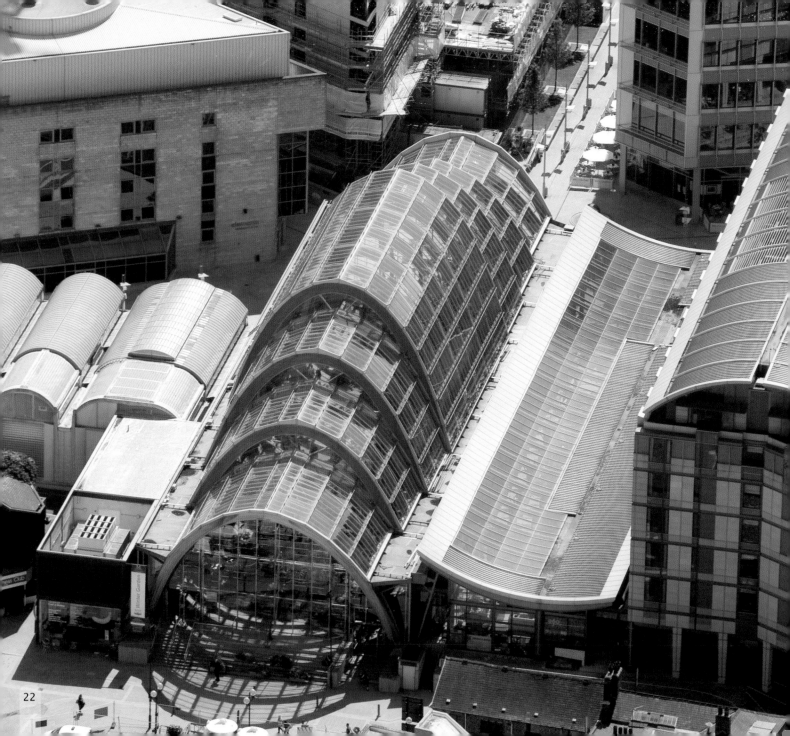

Opposite and above: Situated between the Peace Garden and the Millennium Galleries, the **Winter Garden**, in the heart of the city centre, houses over 2,500 species of plants from around the world and is the largest temperate glasshouse in any city centre in Europe. At 70 metres long, the Winter Garden is one of the largest buildings in the country constructed from a glued laminate of larch wood.

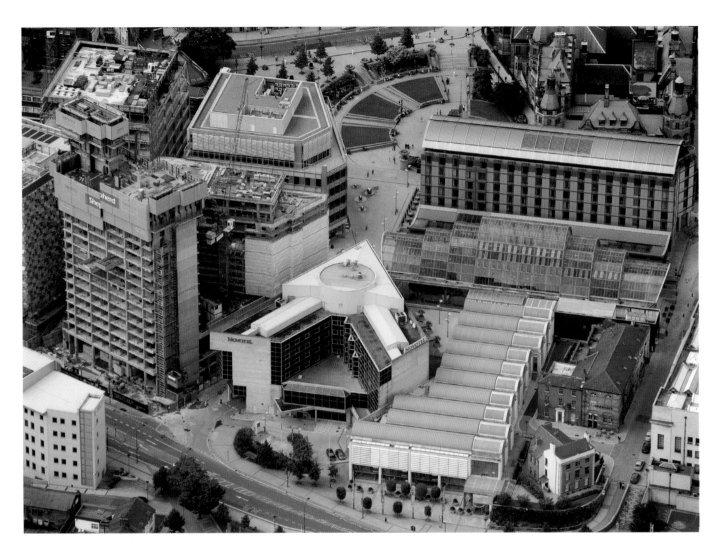

Above: Here on Arundel Gate is **St Paul's Tower** at about half its finished height, the Novotel and the Millennium Galleries.

Opposite: The striking curves of the entrance and water slides of the **Ponds Forge Leisure Centre**.

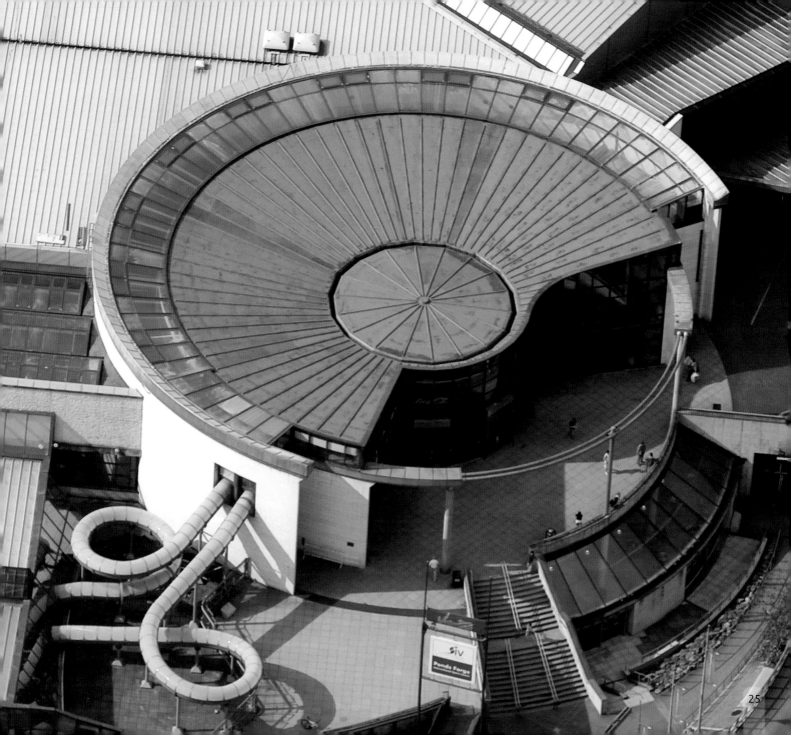

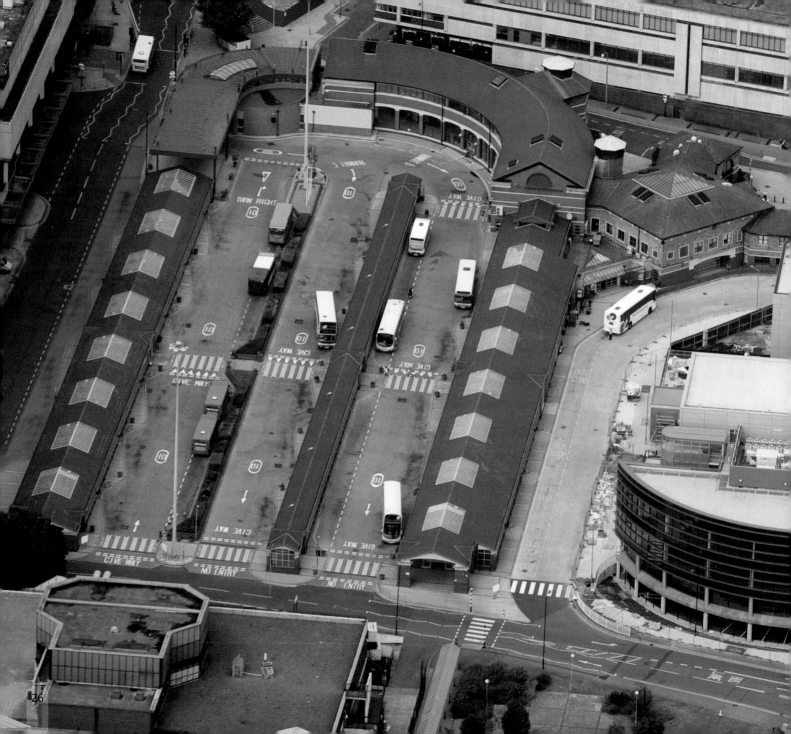

Commerce

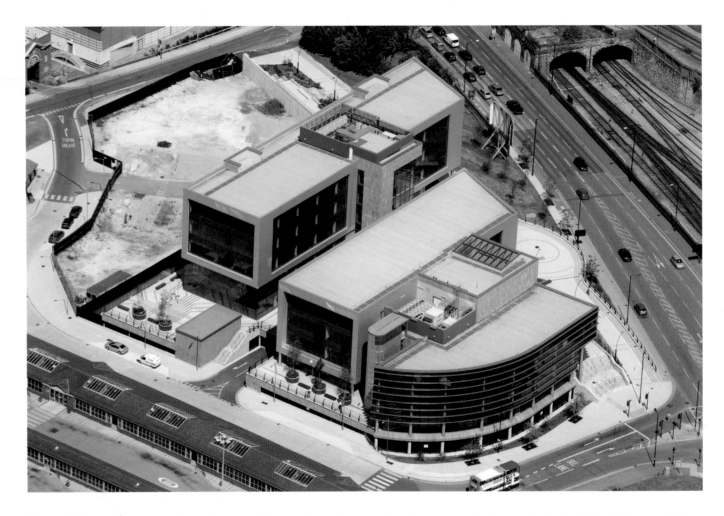

Above: Situated between the railway and bus station, close to the city centre, is the newly built **Digital Campus**. It is a purpose-built IT business centre. It is hoped that it will further promote Sheffield as one of Europe's leading technological centres.

Opposite: Completed in 1972, **Telephone House** on Charter Row houses offices on its 15 floors.

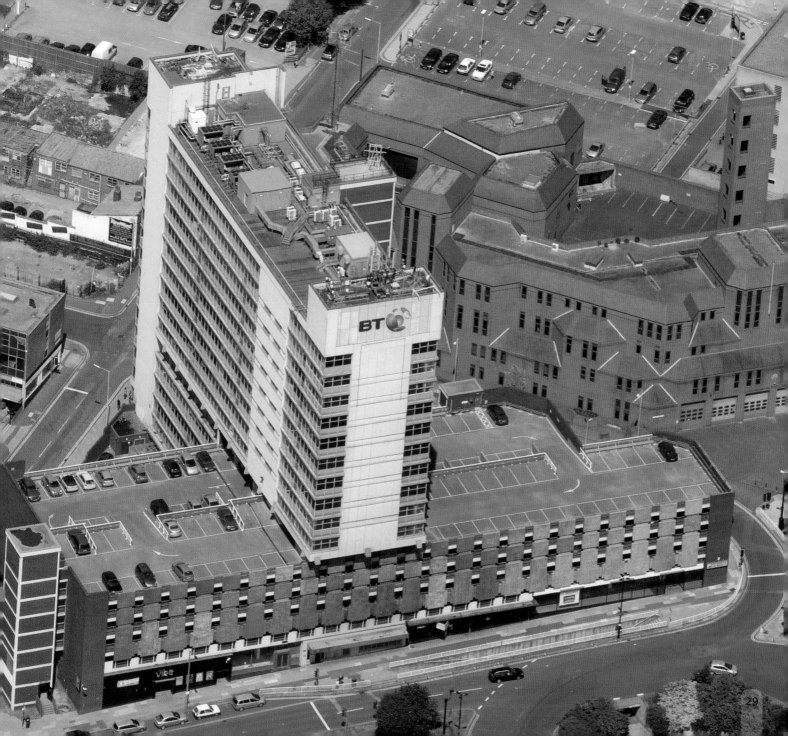

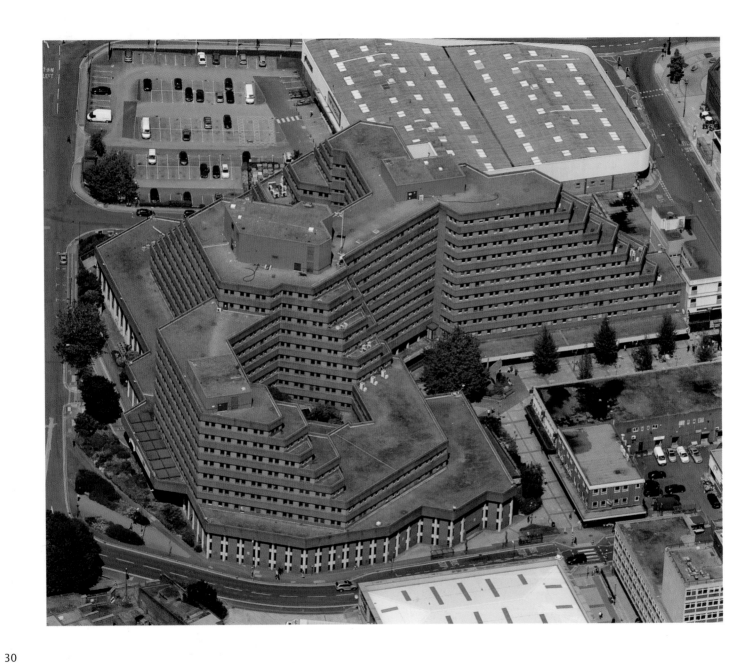

Right: The **Iquarter** is a mixed development of office space and luxury apartments.

Opposite: Built in the form of a step pyramid, the **Moorfoot Building** was opened in July 1981. It is a large office building to the south of the city centre, close to the Inner Ring Road.

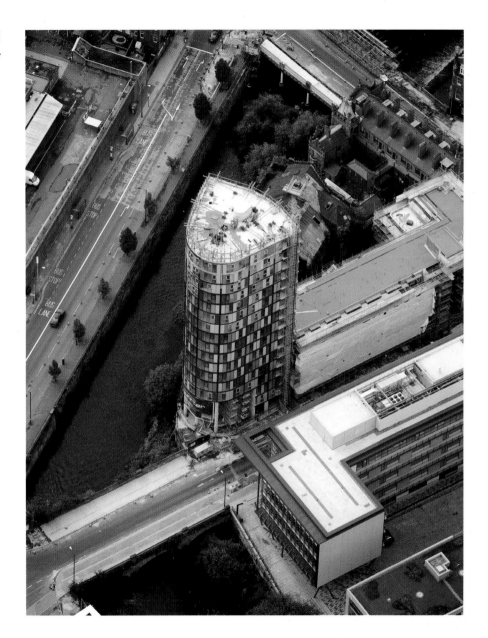

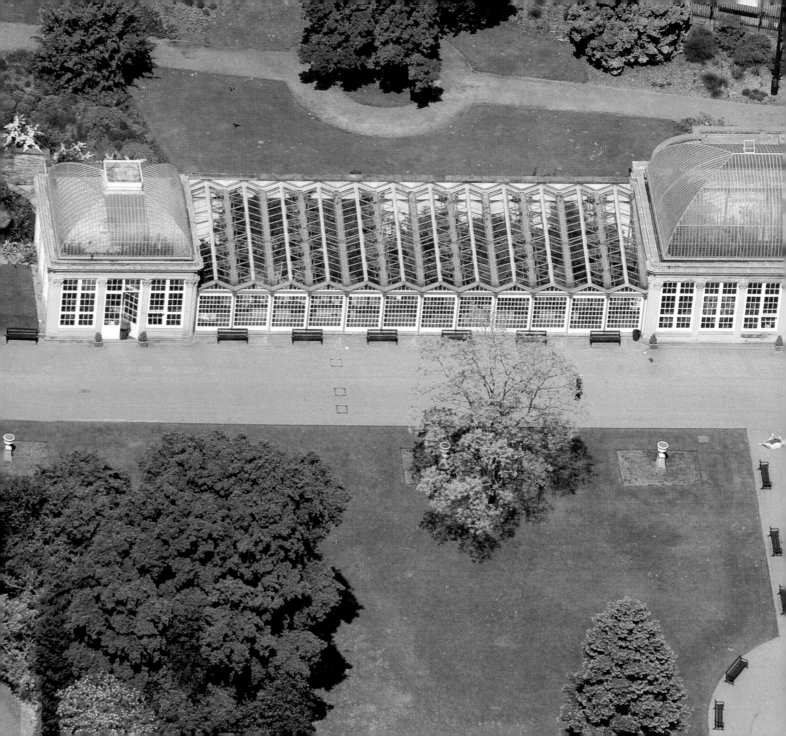

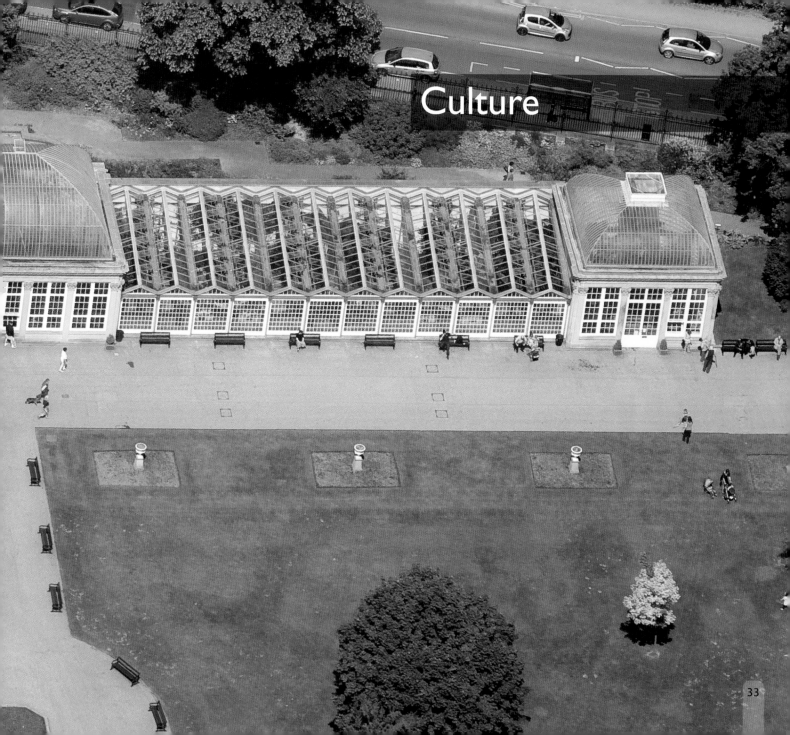

Culture

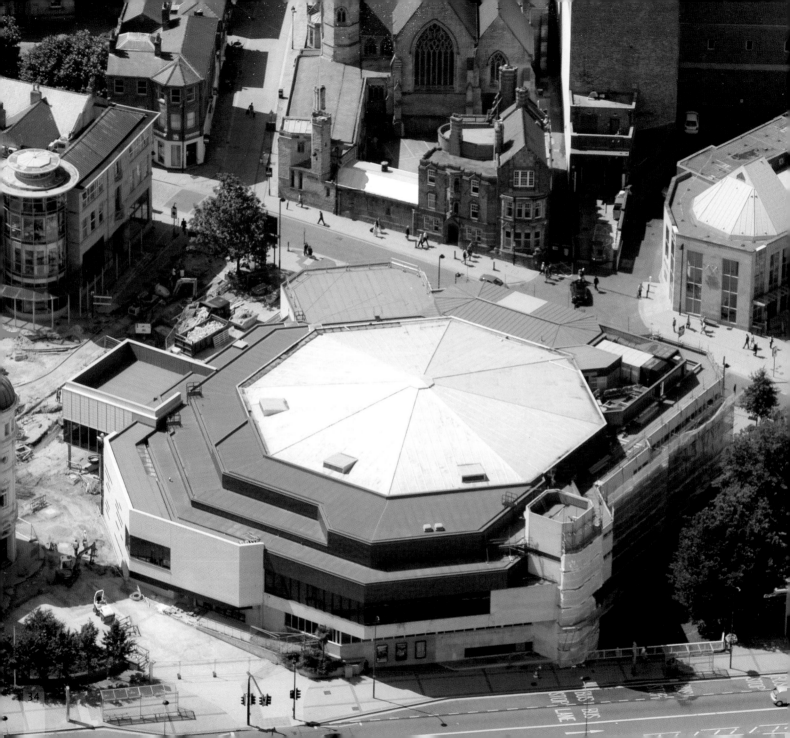

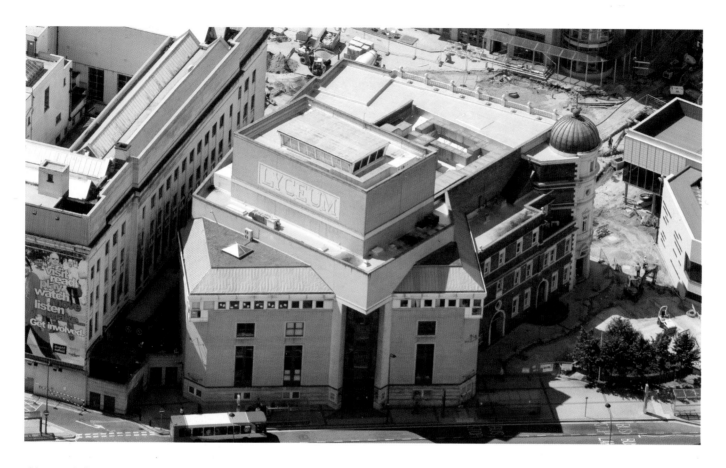

Above: Adjacent to the Crucible Theatre is the **Lyceum Theatre**, built in 1897 to a proscenium arch design. Part of the Sheffield Theatres complex, the Lyceum is the main venue for touring productions in the city.

Opposite: Built in 1971 on the former site of the Adelphi Hotel, the **Crucible Theatre** is known to millions of sports fans as home to the World Snooker Championship. At the time of writing in the Grade II-listed Crucible Theatre building is undergoing an estimated £15 million refurbishment.

Previous page: The **Sheffield Botanical Gardens** Grade II-listed pavilion.

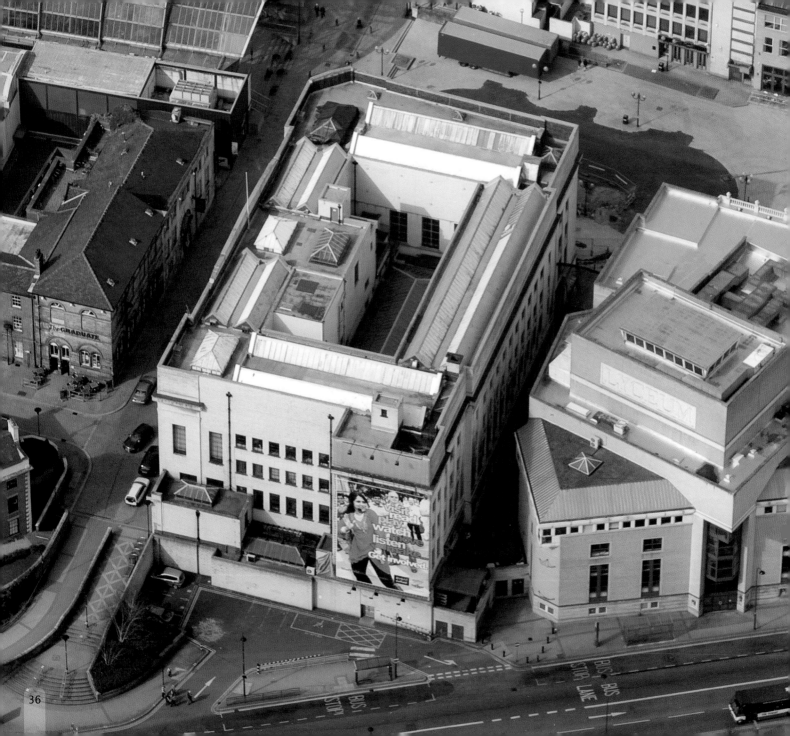

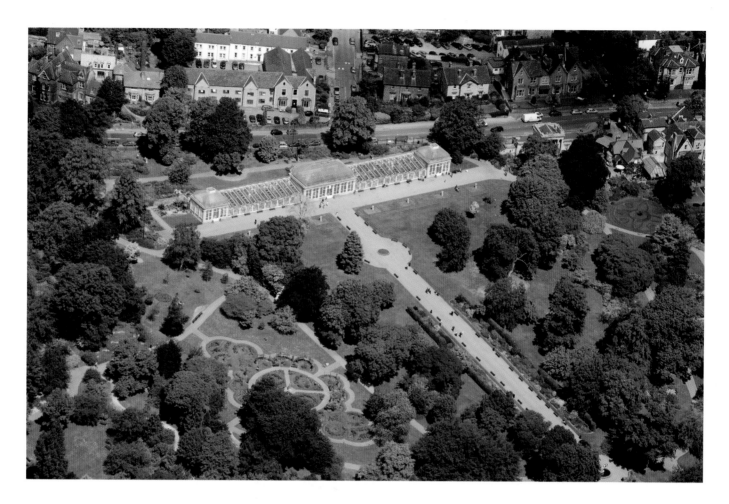

Above: Opened in 1836, the **Sheffield Botanical Gardens** are situated to the south-west of the city and are home to more than 5,000 species of plants. Seen here is the most notable feature of the gardens, the Grade II-listed pavilion. Within the Botanical Gardens are some spectacular flower beds.

Opposite: The **Central Library** is situated next to the Lyceum Theatre on Arundel Gate. As well as being the city's largest lending library, the building also houses an art gallery and a basement theatre.

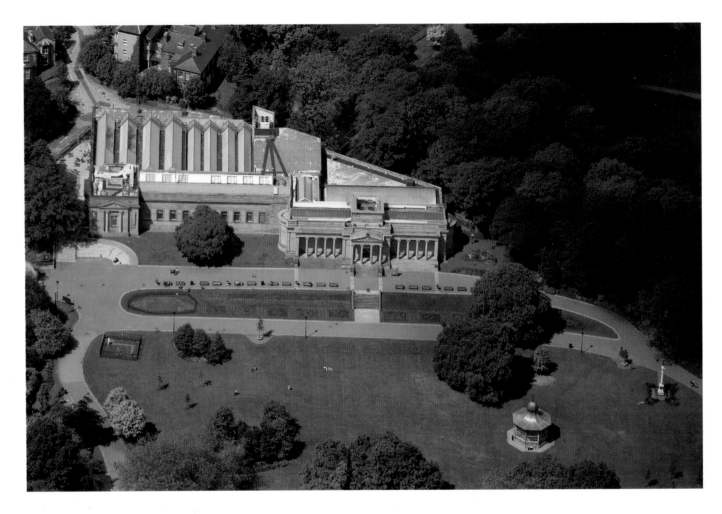

Above: Opened in 1875, the **Weston Park Museum** was originally named the Sheffield City Museum and Mappin Art Gallery.

Opposite: The restored **bandstand in Weston Park** is an approved venue for civil weddings. Here wedding guests await the arrival of the bridal party.

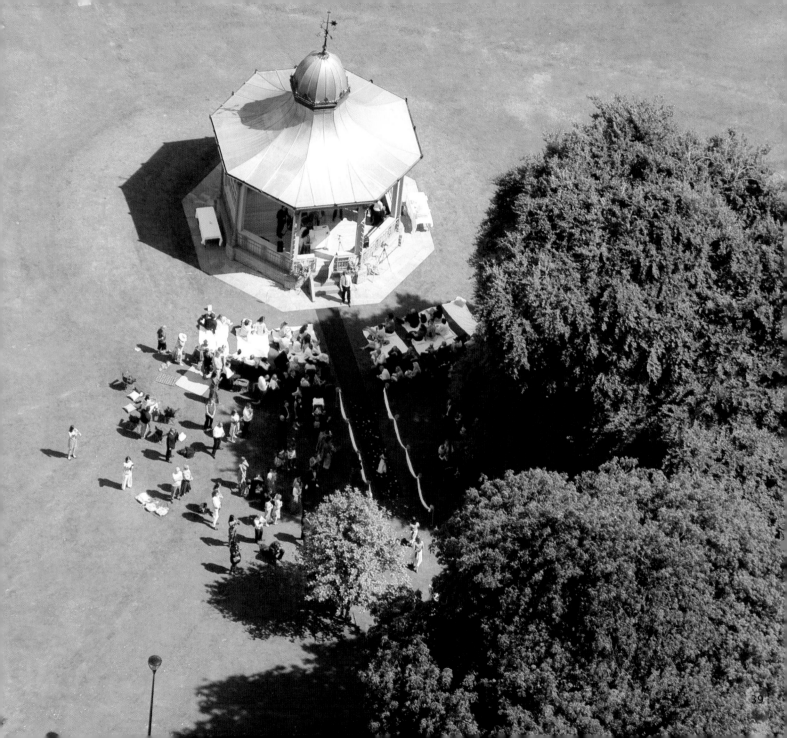

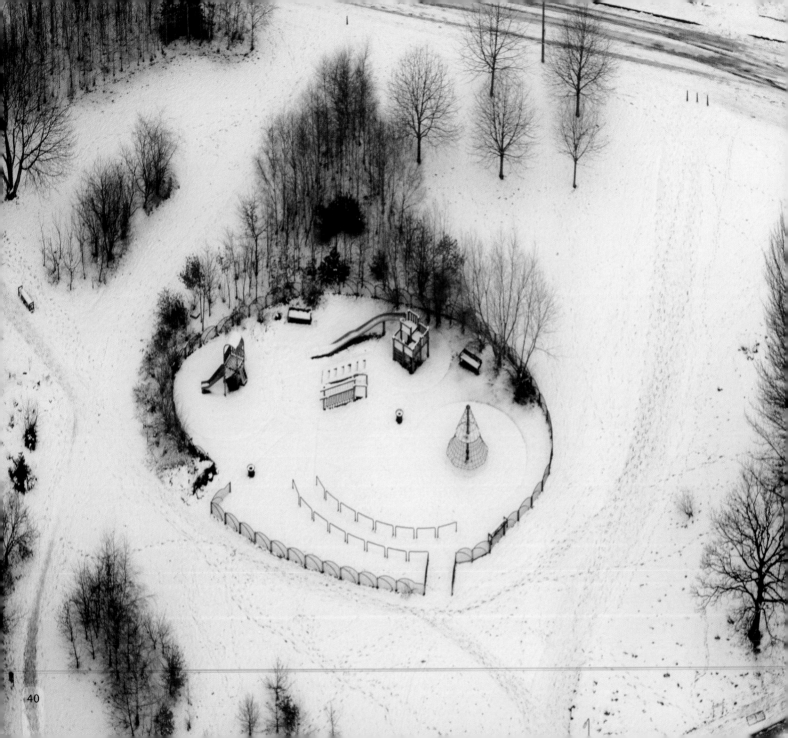

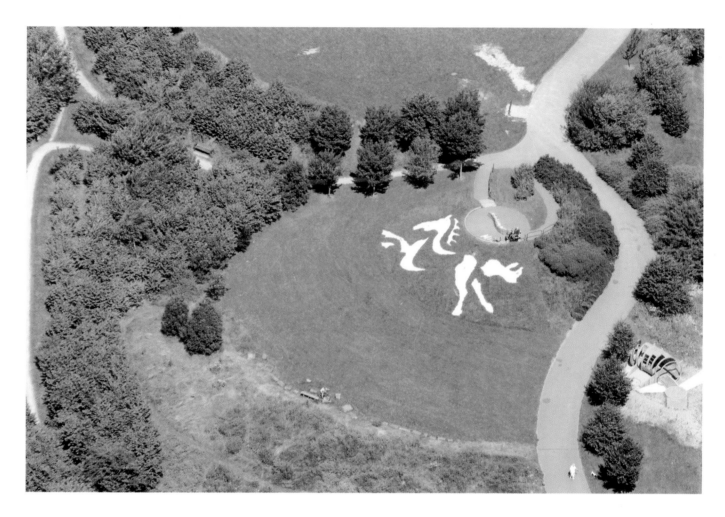

Above: Seen here in **Heeley Millennium Park** is a carved white horse, which was unveiled to the public on 1 May 2000. Despite its chalk-like appearance, it is in fact concrete painted white.

Opposite: Snow-covered playground in Heeley Millennium Park.

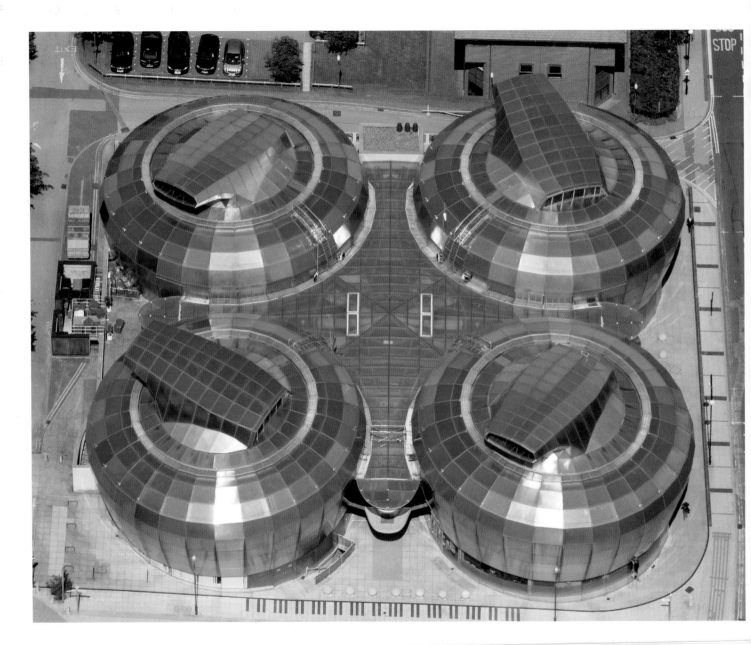

Above and opposite: Formerly known as the National Centre for Popular Music, the **HUBs** as it is now known was open as a museum for less than two years. The building was bought by Hallam University in 2003 and now houses the Student Union.

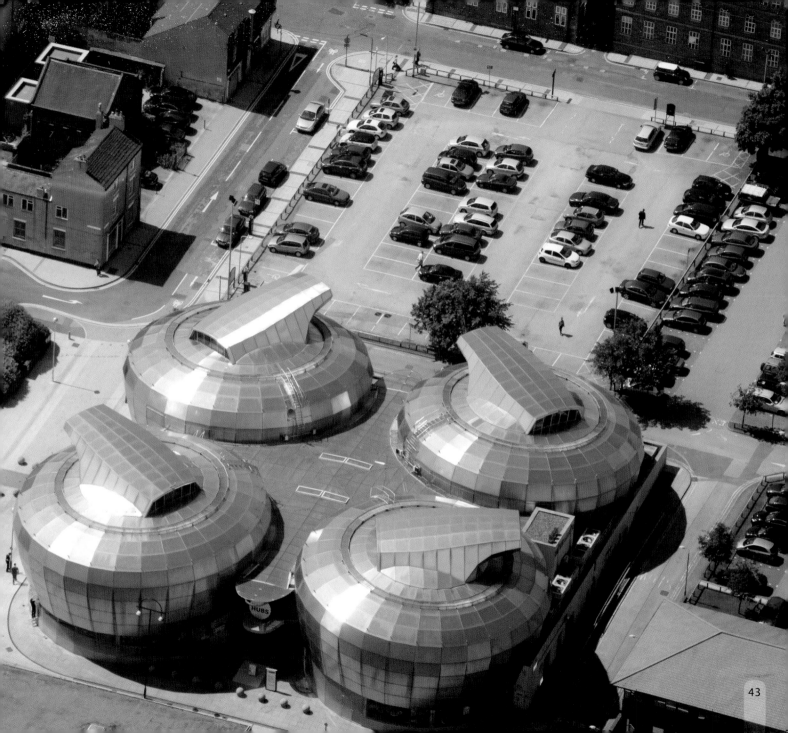

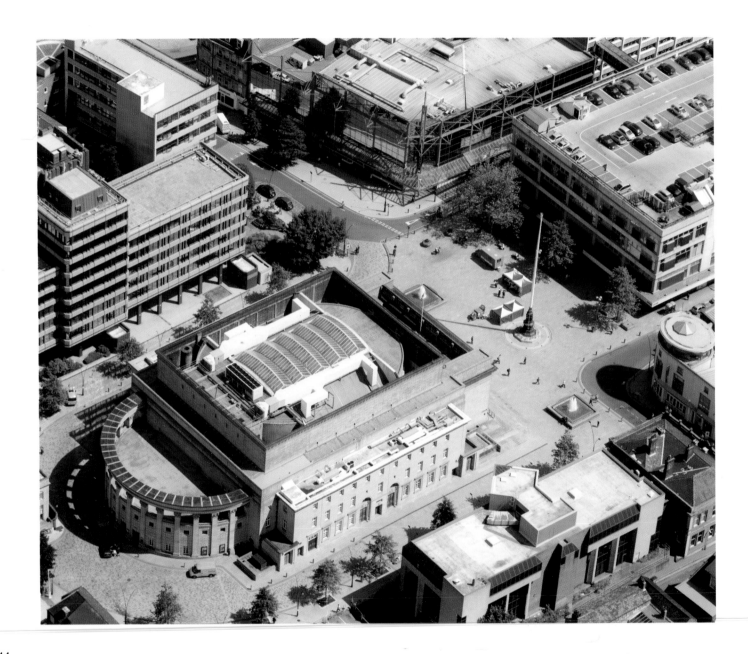

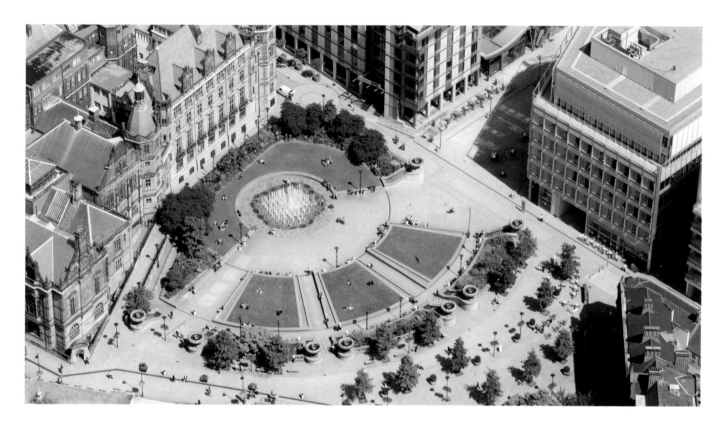

Above: When St Paul's Church was demolished in 1938 to make way for Town Hall extensions, a temporary garden was created. This is now known as the **Peace Gardens.** The gardens contain several monuments to the city's past including the Goodwin Fountain, Holberry Cascades and the Spanish Civil War monument.

Opposite: Sheffield City Hall is another of the city's grade II-listed buildings. It contains several venues, the largest of which is the Oval Concert Hall, which can seat over 2,000 people.

Overleaf: The **Millennium Galleries** were opened in April 2001 and are a collection of four galleries under one roof. As well as a traditional art gallery and a gallery to house major travelling exhibitions, there is a gallery dedicated to decorative and domestic metalwork, which the city was famed for worldwide.

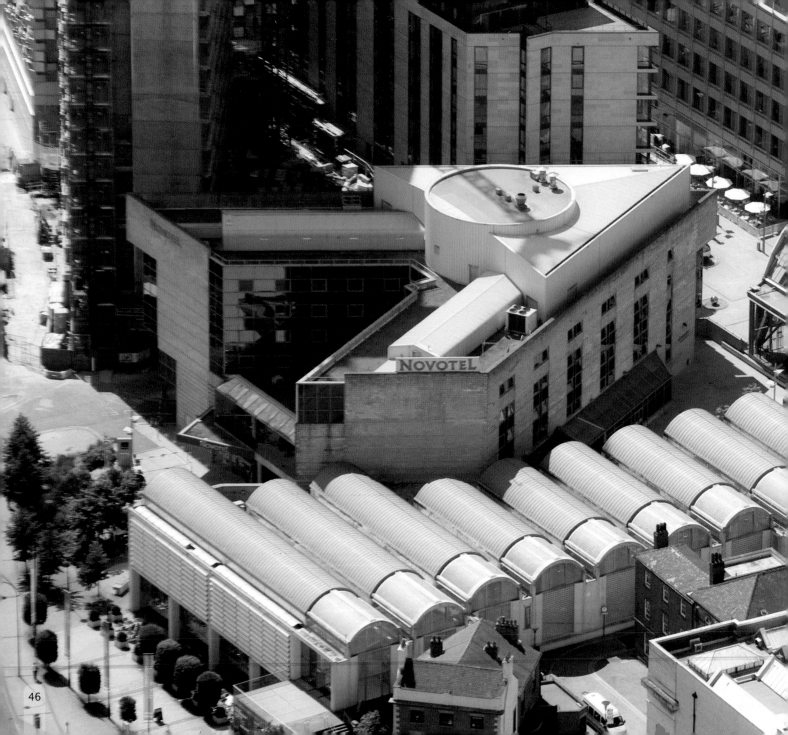

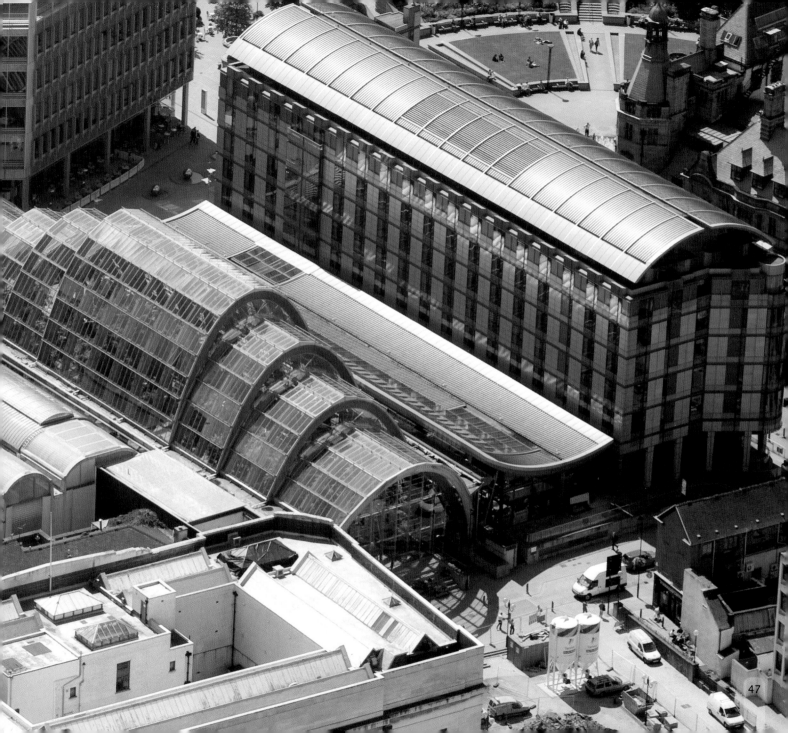

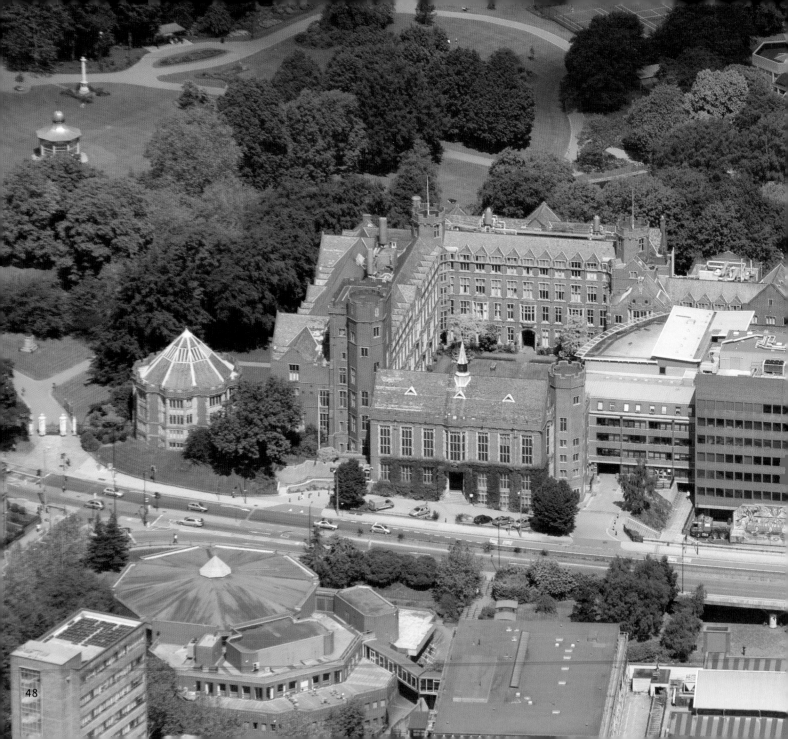

Education

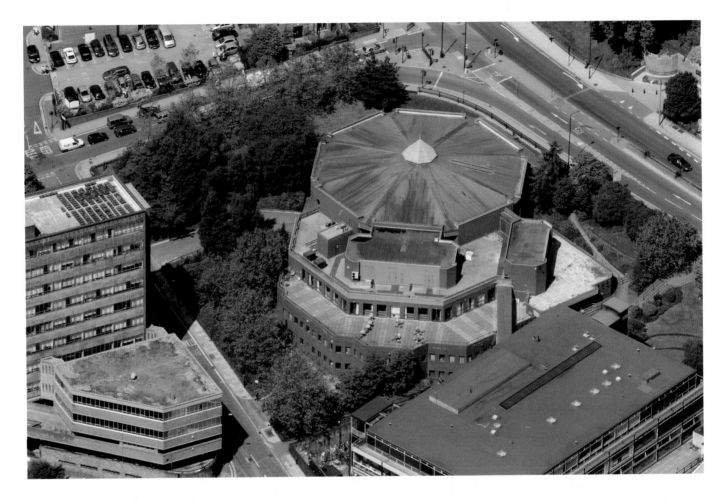

Above: As the name suggests, the **Octagon Centre** is an eight-sided auditorium with offices and a lounge bar and is currently used as a conference and music venue. It is situated in the Western Bank campus of the University of Sheffield and as a university building it is used for lectures, examinations and graduation ceremonies.

Previous page: University of Sheffield buildings including the Octagon Centre, University House, the Arts Tower, the Alfred Denny Building, the Addison Building and Firth Court.

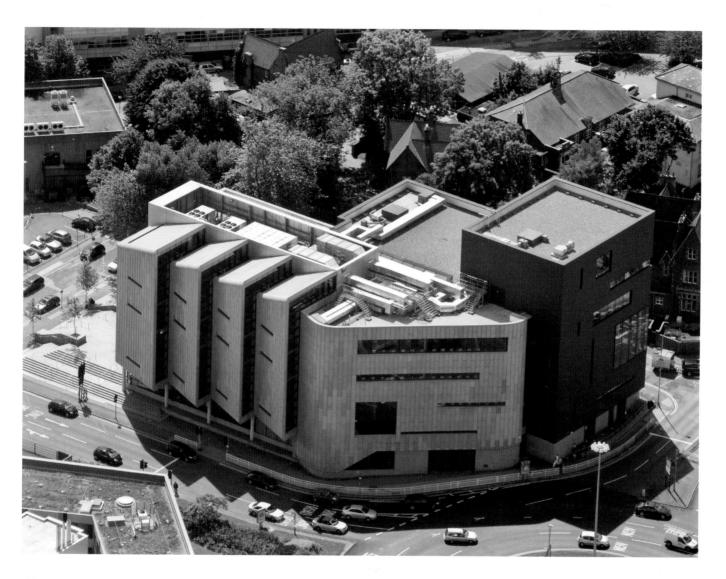

Above: Open 24 hours a day to students, the **Information Commons** is a building of the University of Sheffield and houses over 1,300 study spaces and 500 computers.

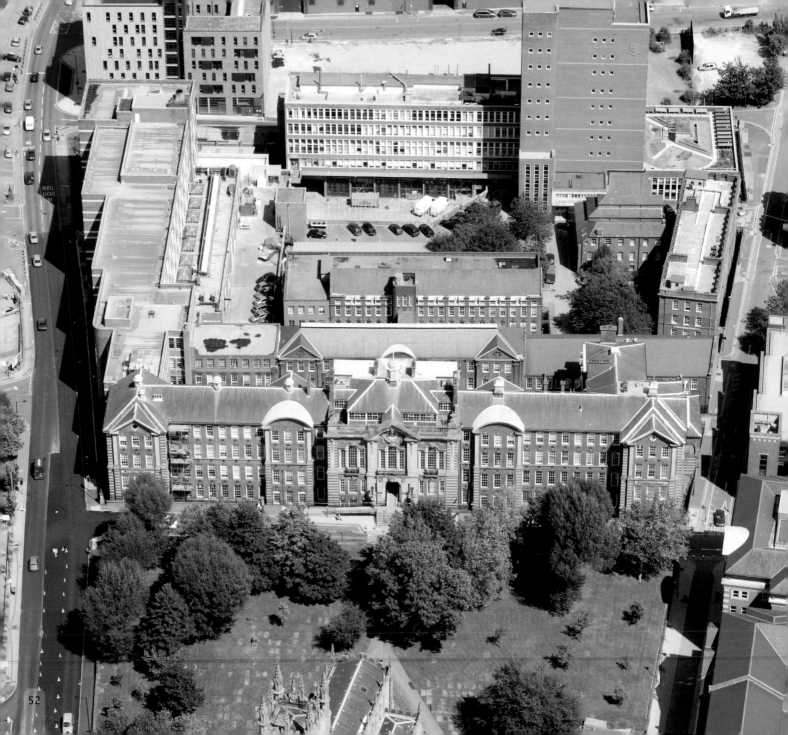

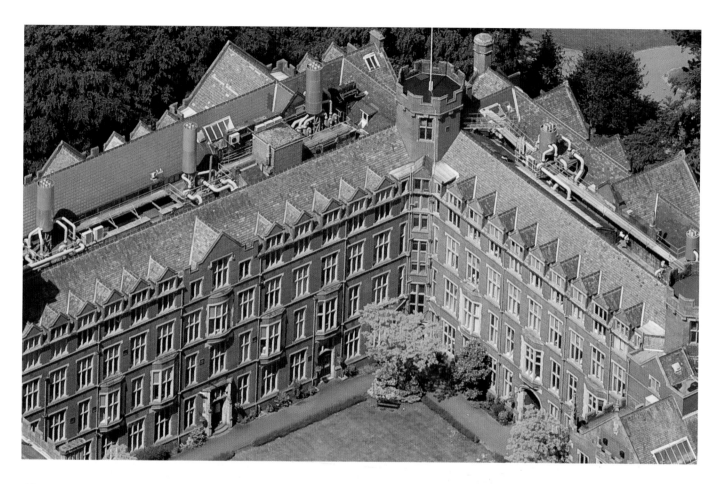

Above: Named after the Sheffield steel manufacturer Mark Firth, who played a key role in Sheffield University's early development, **Firth Court** is the main administrative centre for the University of Sheffield. The building was opened by King Edward VII and Queen Alexandra in 1905.

Opposite: Widely regarded as the founder of Sheffield University, Sir Frederick Mappin gave his name to the **University of Sheffield Mappin Building,** which was opened in 1904 and is now a Grade II-listed building. It currently houses the University departments of electronic, electrical and mechanical engineering.

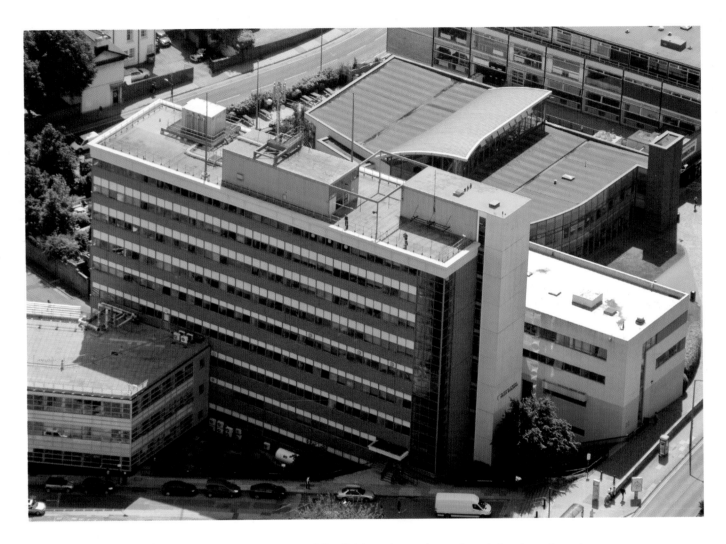

Above: The **Hicks Building** houses the University of Sheffield mathematics and statistics departments.

Opposite: Sheffield Springs Academy moved into its purpose-built facility in 2008. The academy is located to the south-east of the city and specialises in performing arts for 11 to 19-year-olds.

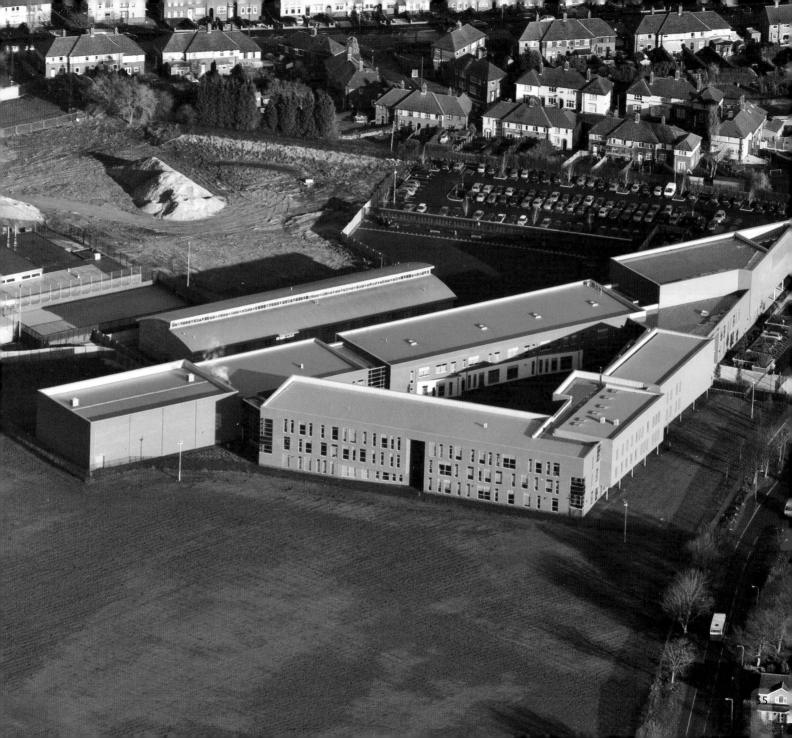

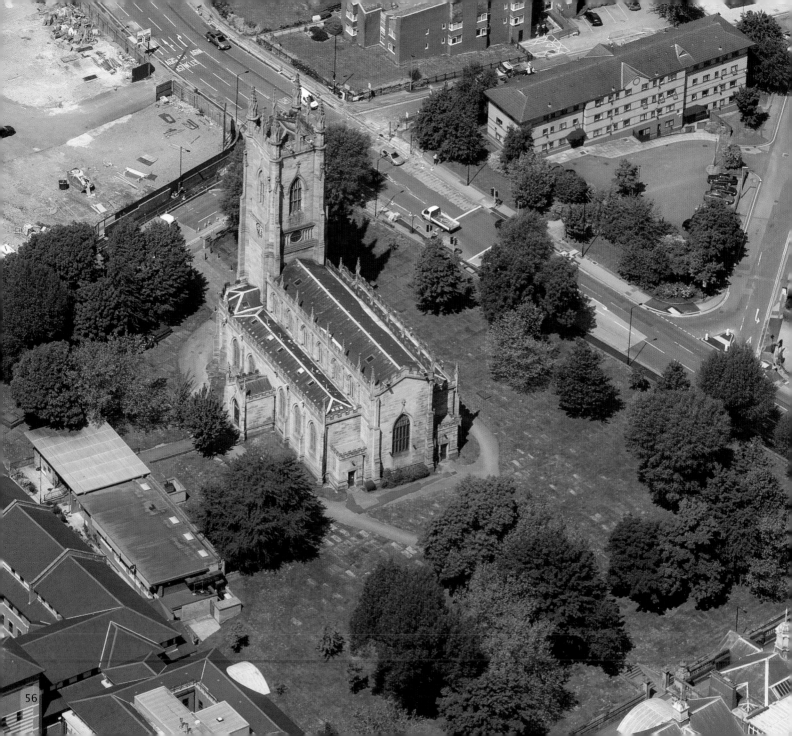

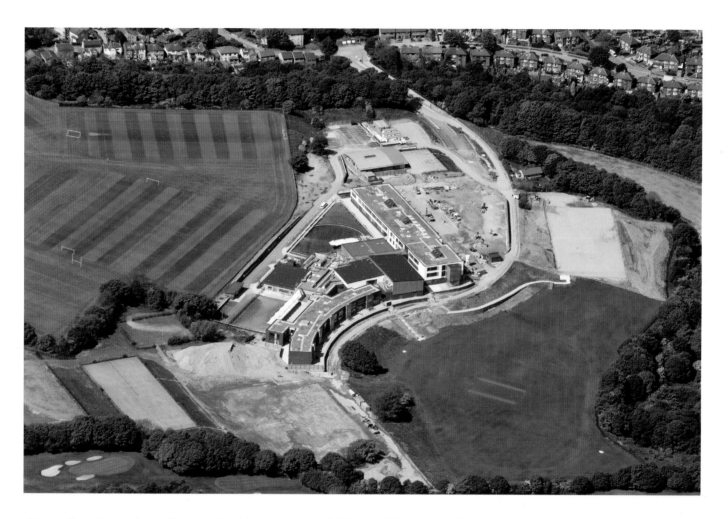

Above: Seen here about 4km south of the city centre is **Newfield Secondary School.**

Opposite: Probably the most unusual student accommodation in the city is to be found within **St George's Church, Portobello.** The church closed in 1981 and was acquired by the University of Sheffield. It is now used as student accomodation and as a lecture theatre.

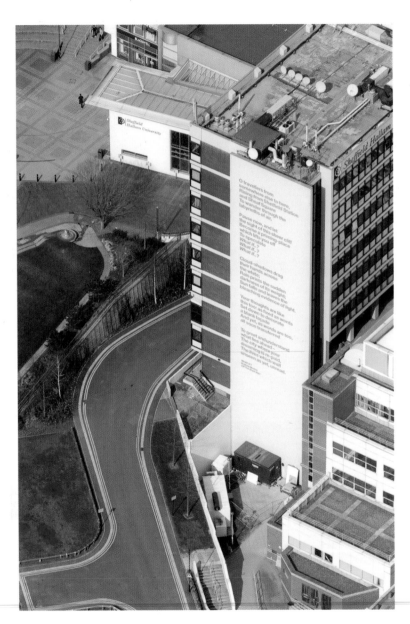

Opposite : The **Jessop West site**, opened in 2008, houses the departments of Modern Languages, History and English. The building has been designed to be environmentally friendly and, as can be seen in the photo, has a living, planted roof covering. The ground floor also has a café, which is open to the public.

Right: *What if?* A poem by Poet Laureate Andrew Motion is seen here painted on the end of the **Sheffield Hallam University building** on Arundel Gate in the city centre.

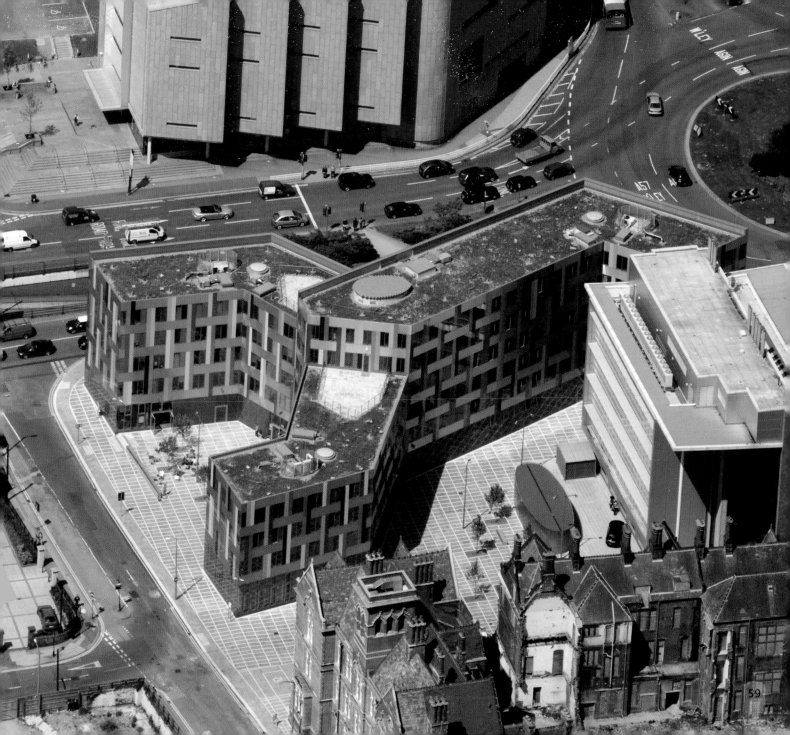

59

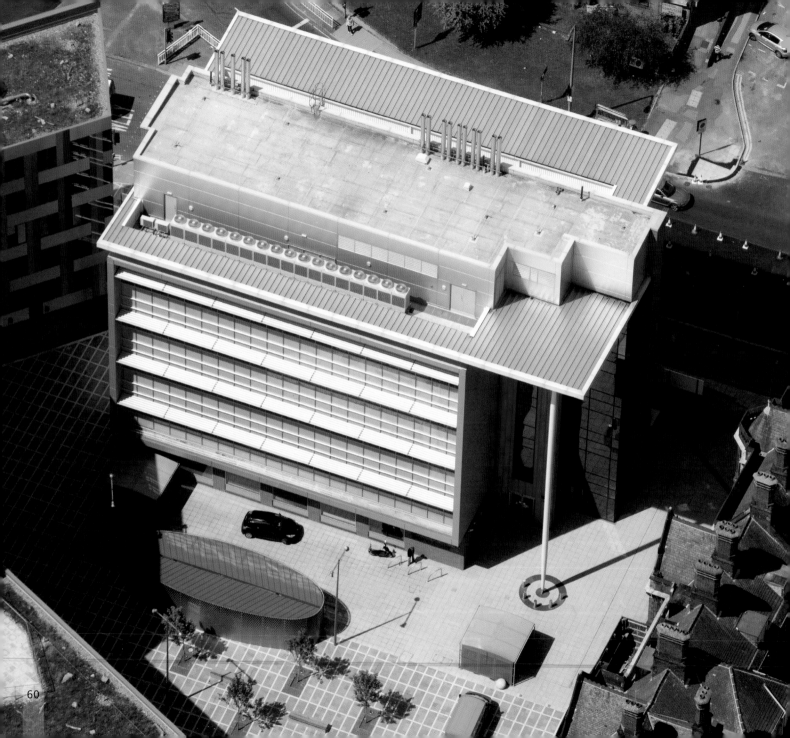

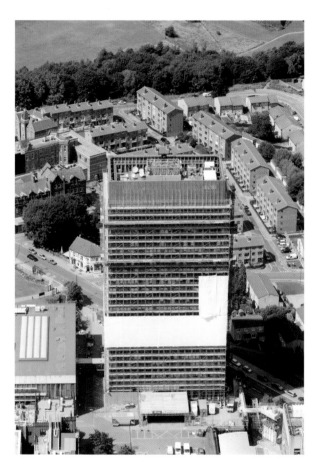

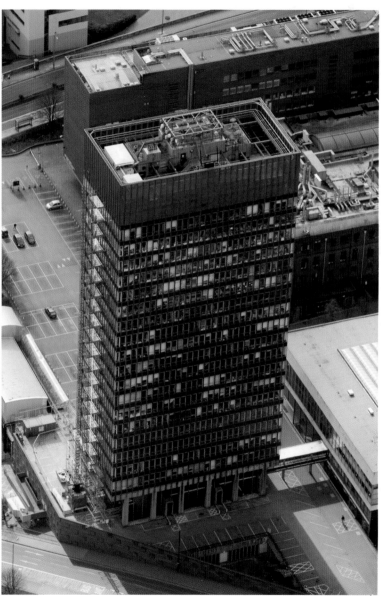

Above, right: The **Arts Tower** is currently undergoing a major refurbishment. It was once described as the most elegant university tower block in the UK.

Opposite: Opened in 2006, the **Bioincubator building** on Broad Street is a purpose-built bioscience site.

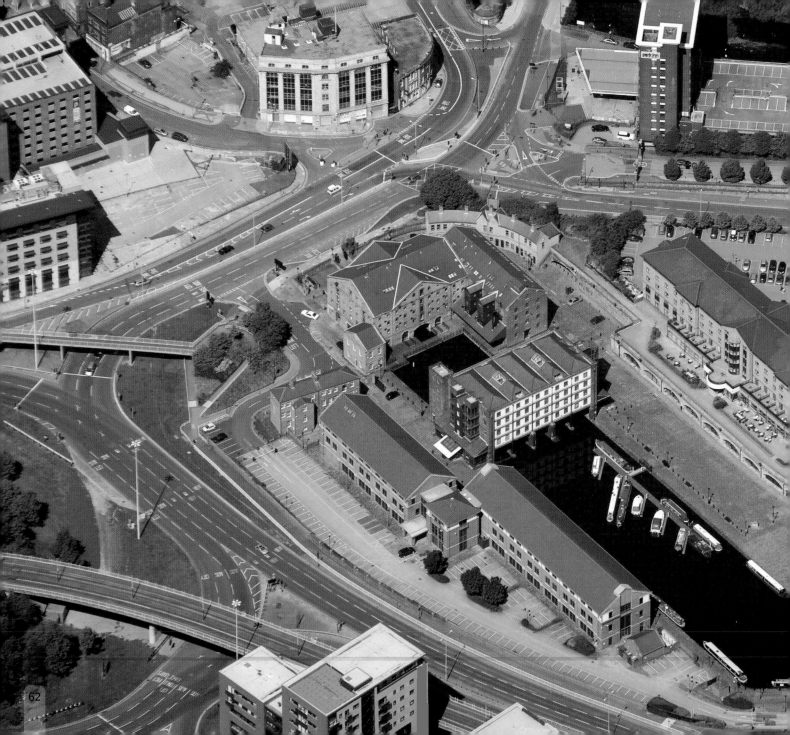

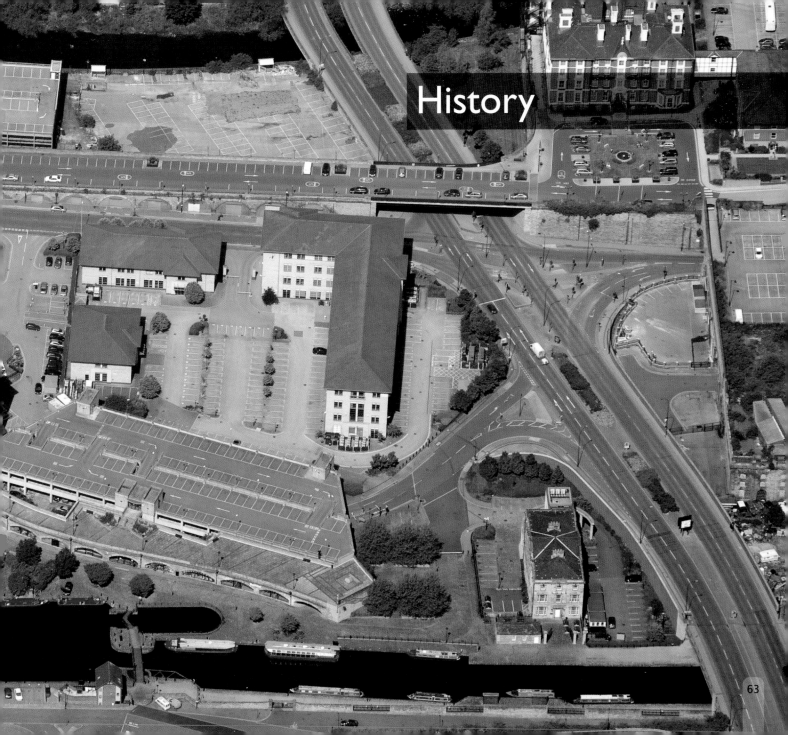

Above: Wincobank Iron Age hill fort stands on the summit of a steep hill above the River Don, north-east of the city. It is oval in shape and covers about 10,000 square metres and was thought to have been constructed by the Celtic Brigantes tribe in around 500 BC.

Previous page: Victoria Quays.

Opposite: Sheffield City Hall is a Grade II-listed building which was completed in 1932. During World War Two a bomb exploded nearby and damaged the pillars seen at the front of the Art Deco portico.

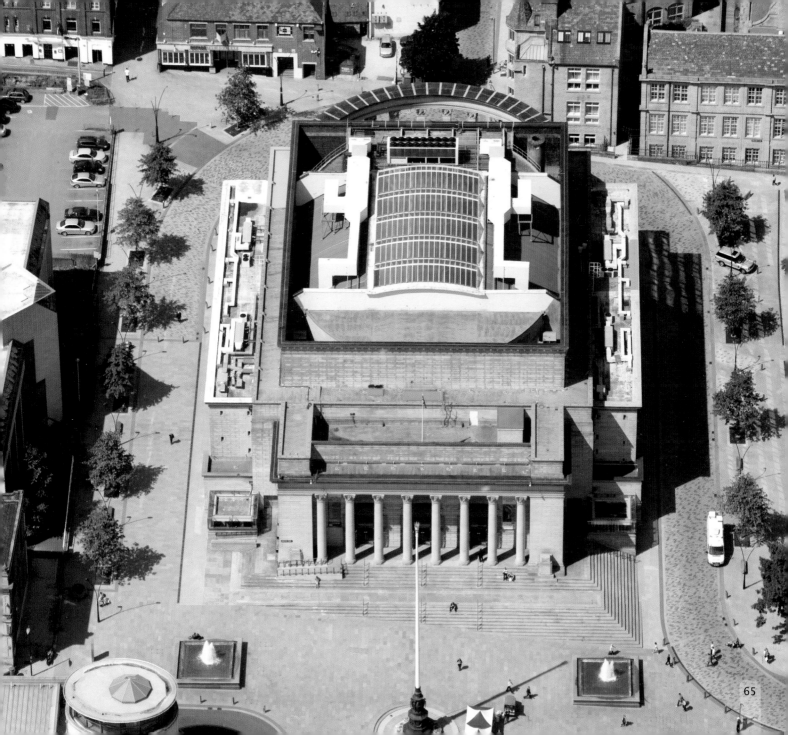

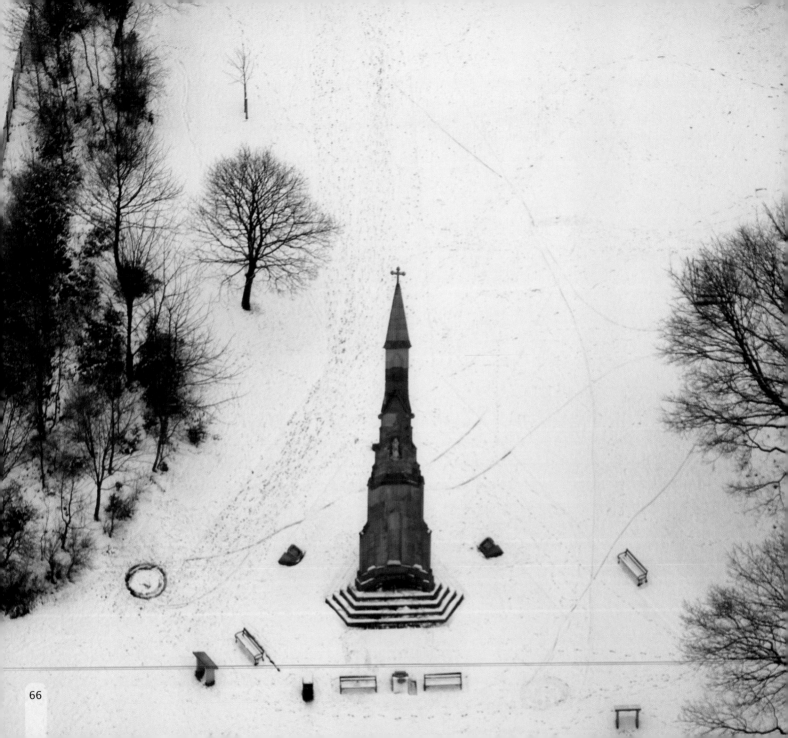

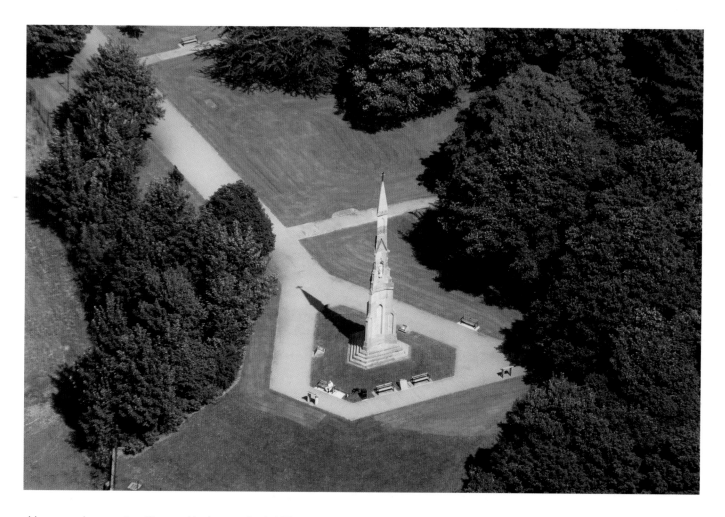

Above and opposite: Situated between Park Hill and Norfolk Park is the **Cholera Monument**. It was completed in 1835 as a memorial to the 402 victims who died in the epidemic of 1832. The foundation stone was laid by the poet James Montgomery.

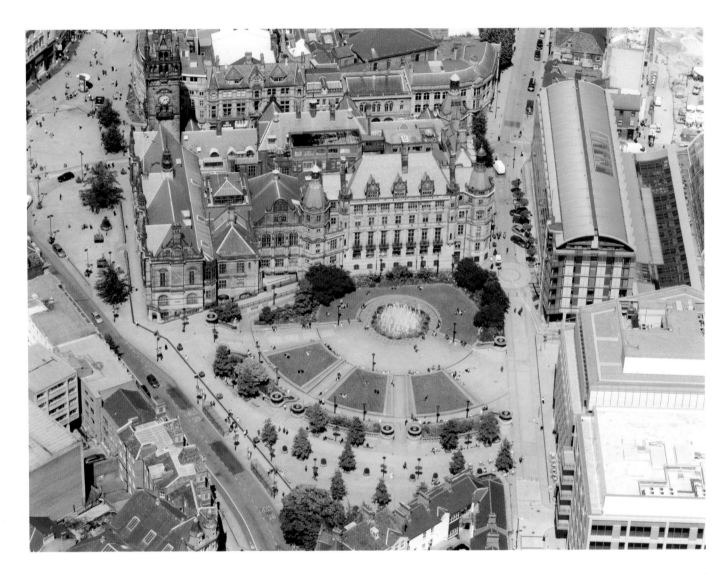

Above: Opened by Queen Victoria in 1897, **Sheffield Town Hall** is used by the City Council. In the north-west corner of the Town Hall stands the 64m clock tower (opposite).

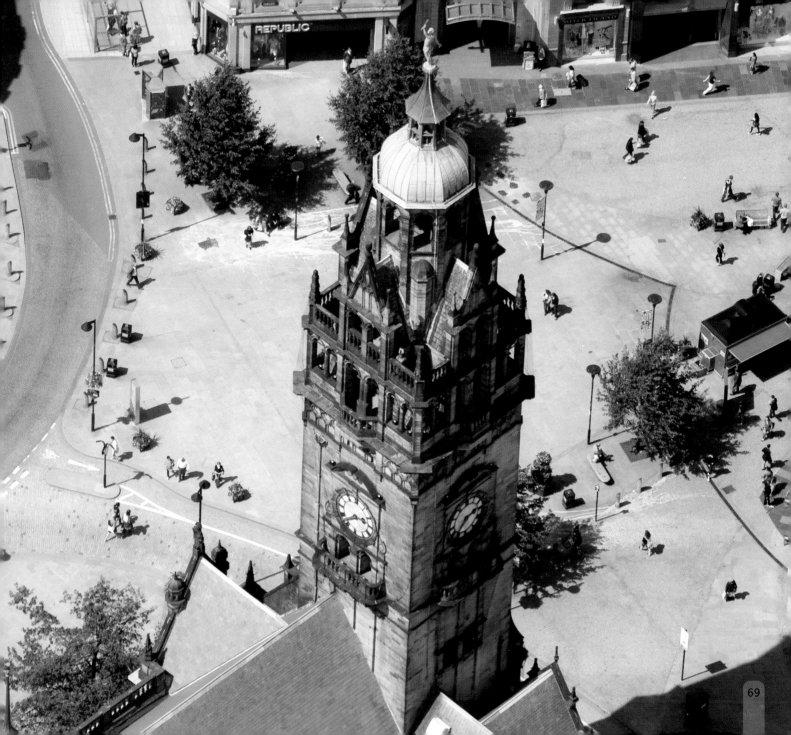

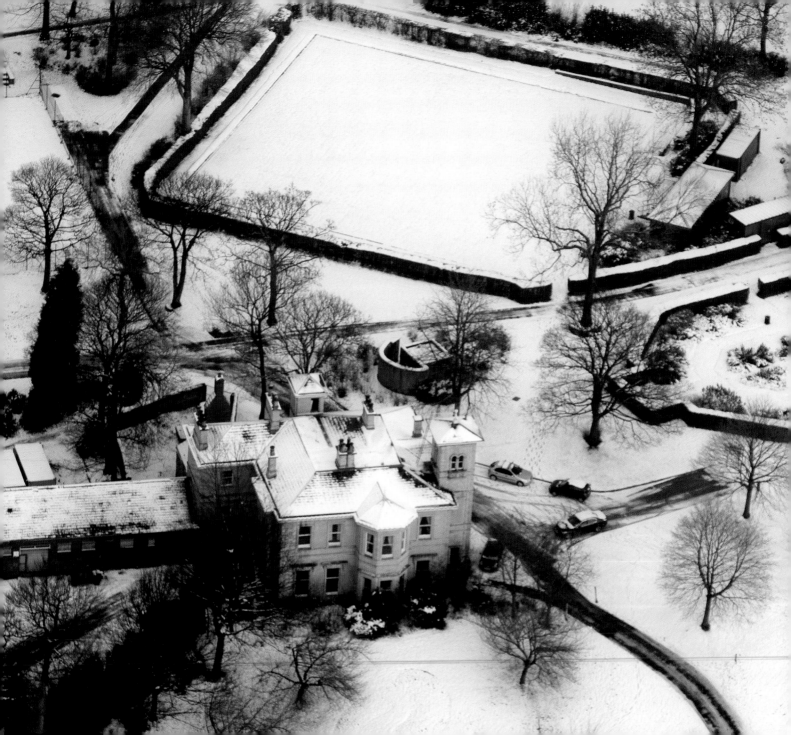

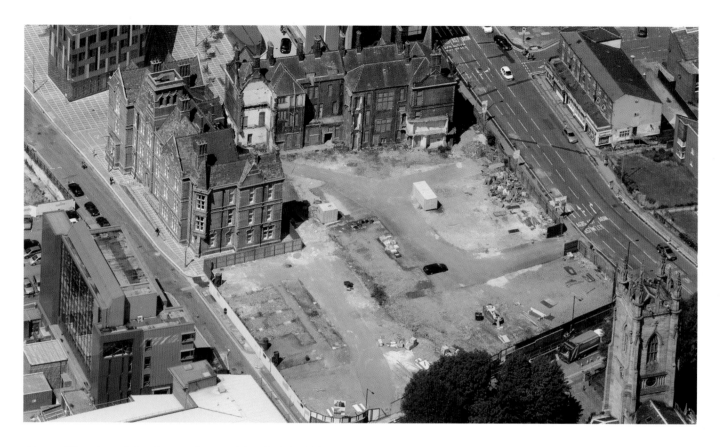

Above: The site of the former Jessop Hospital for Women. It was named after Thomas Jessop, a well-known public figure in the city who held such positions as Master Cutler and Mayor. The original Victorian building remains and is now owned by the University of Sheffield. Once renovations are completed it will be used to house the department of music.

Opposite: High Hazels House is located in High Hazels Park in the Darnall area and was built in 1850 by William Jeffcock, the first Lord Mayor of Sheffield. The park is owned by Sheffield City Council and the house is currently used by the Tinsley Golf Club.

Overleaf: Seen here after heavy snow fall is **Burngreave Cemetary and War Memorial**.

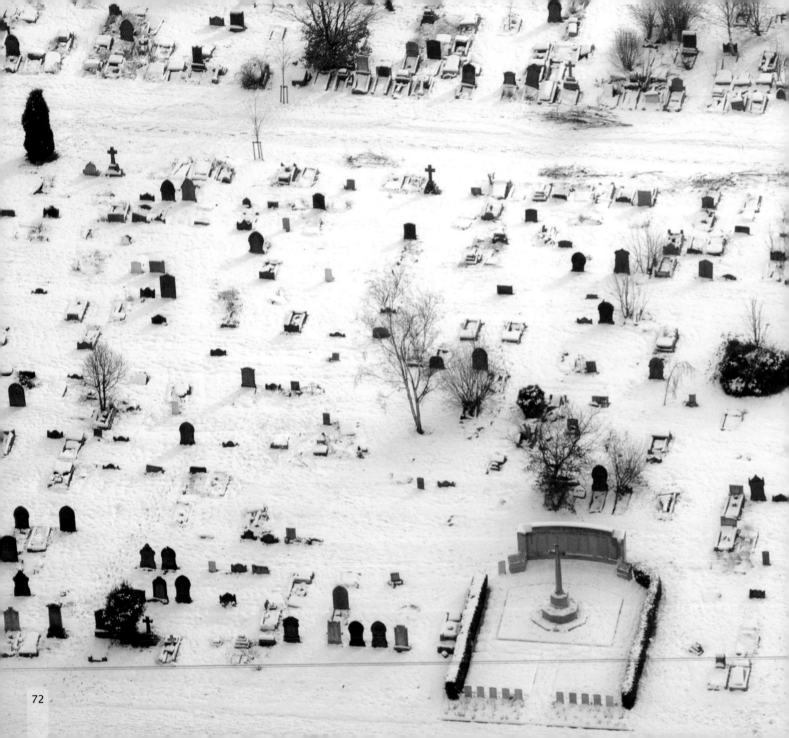

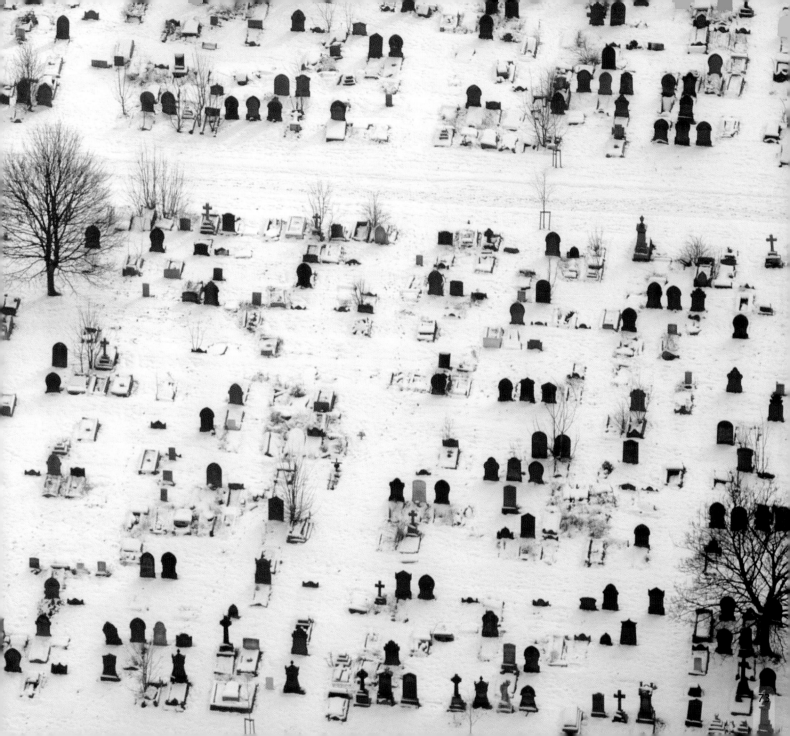

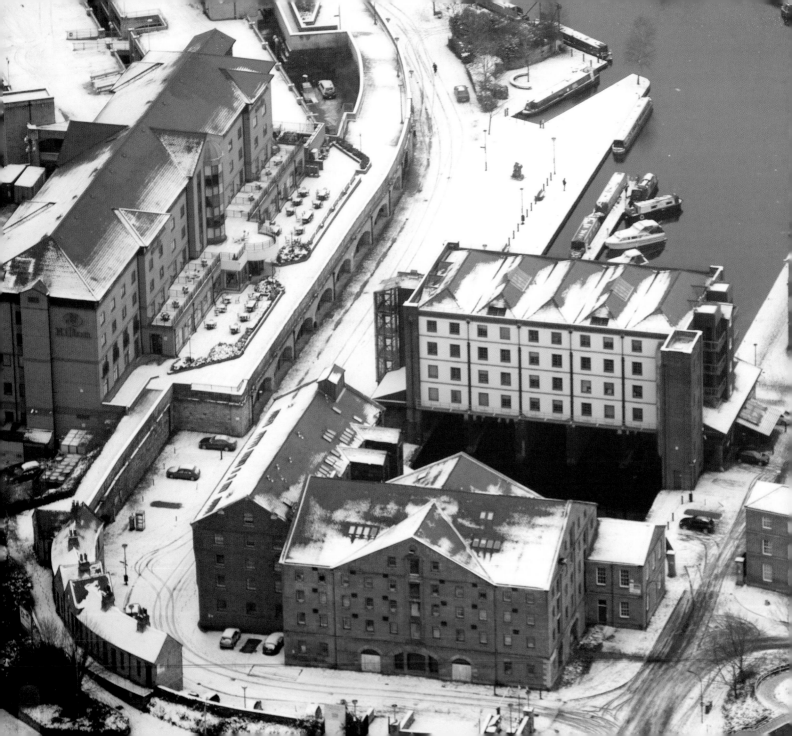

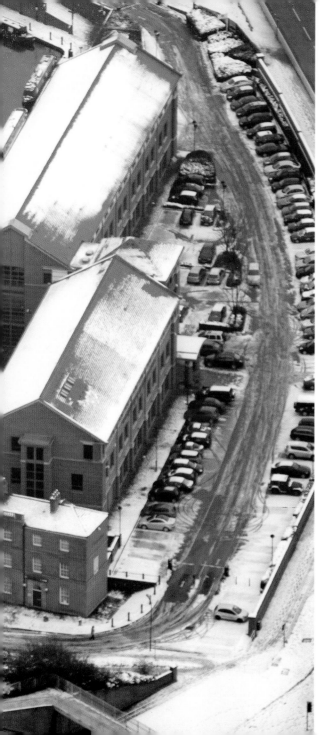

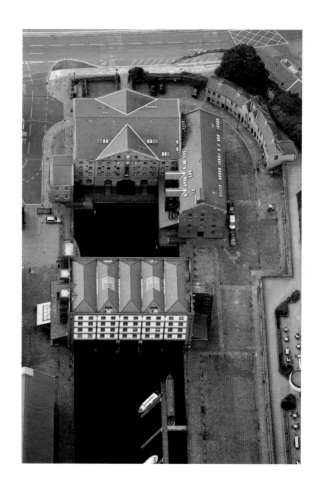

Left and above: Victoria Quays (formerly Sheffield Canal Basin) was constructed 1816–19 as the terminus of the Sheffield Canal and ceased operation as a cargo port in 1970. After a major restoration and redevelopment in the early 1990s, the site reopened providing new office and business space as well as canal boat moorings.

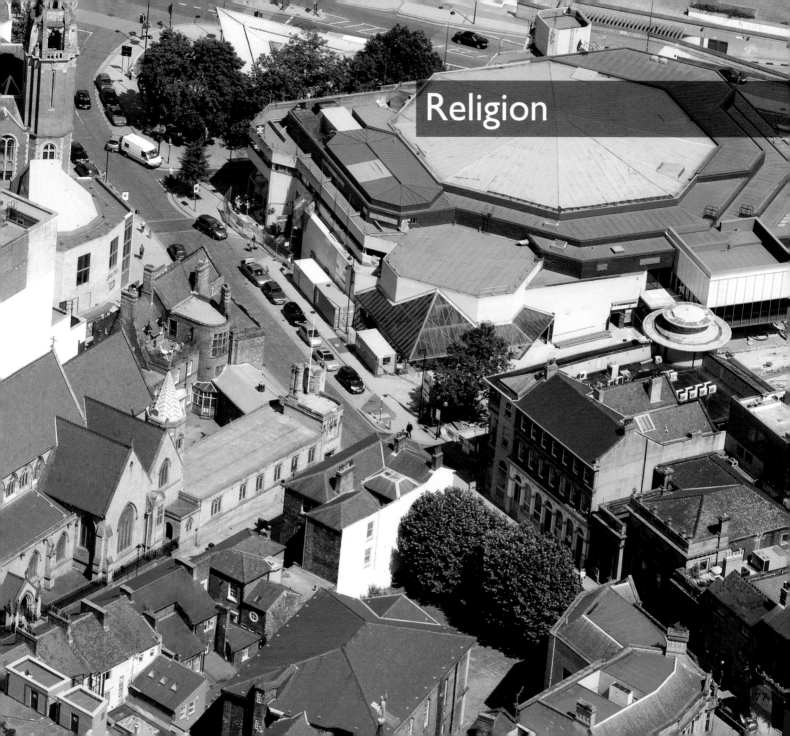

Religion

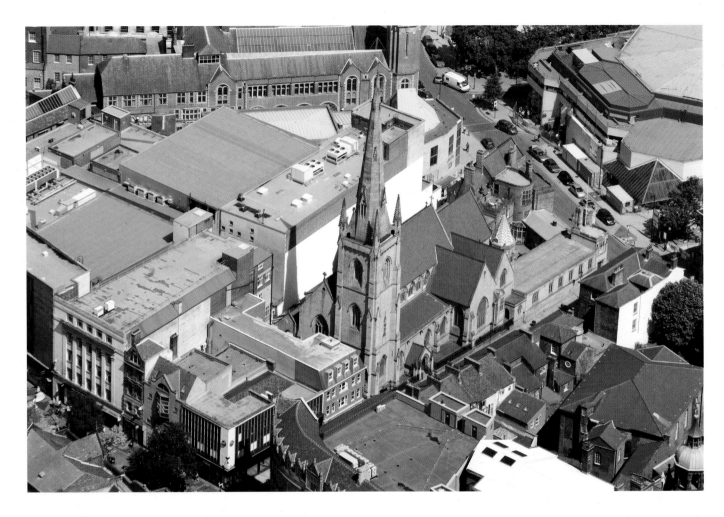

Previous page and above: Situated in the city centre on Norfolk Row and dating from the middle of the 19th century is the **Roman Catholic Cathedral Church of St Marie**. It was granted cathedral status in May 1980.

Opposite: The **Church of St Peter and St Paul** is more commonly called Sheffield Cathedral. It is situated in the city centre on Church Street. The site is thought to have been a place of worship for over 1,000 years.

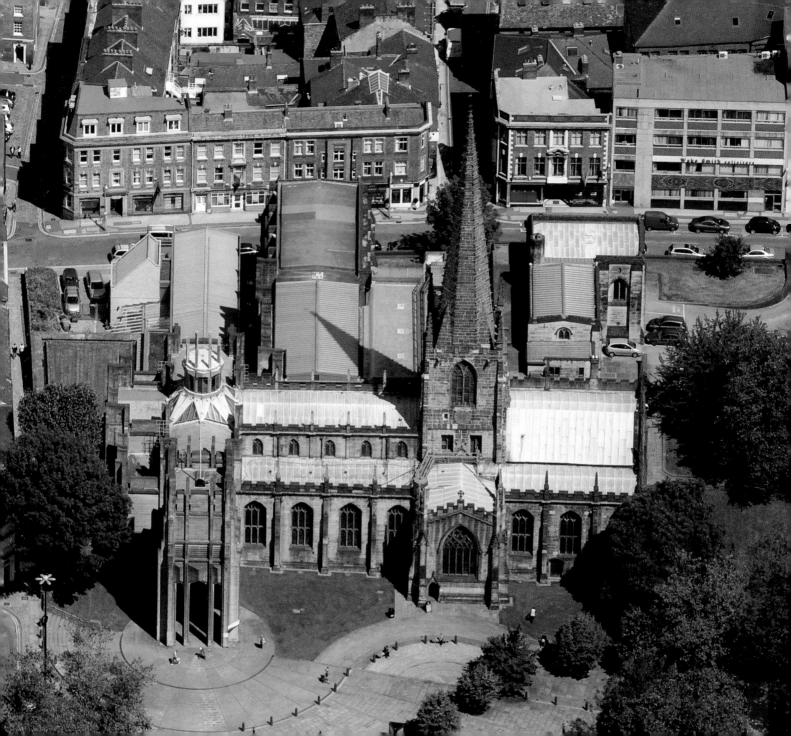

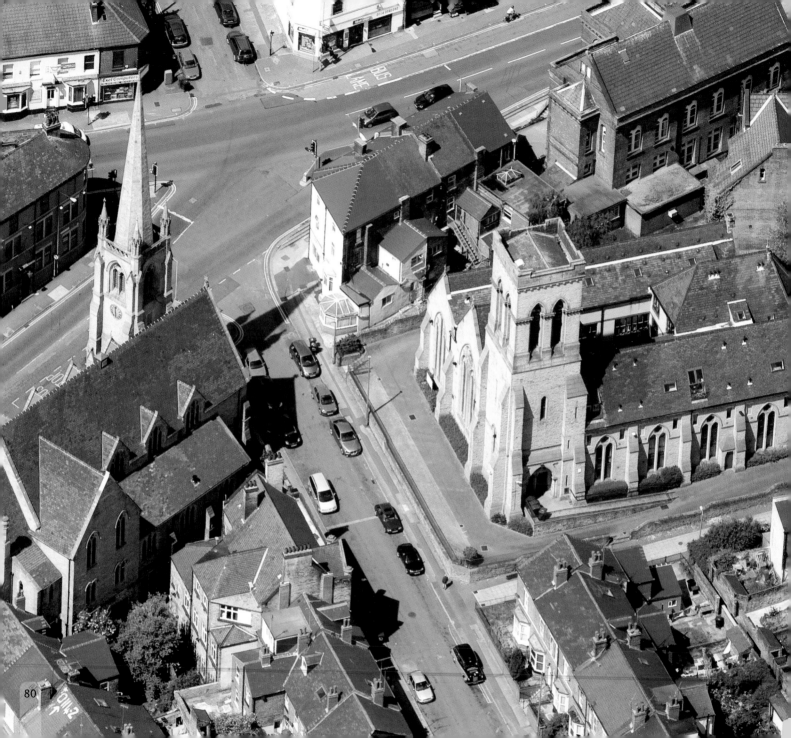

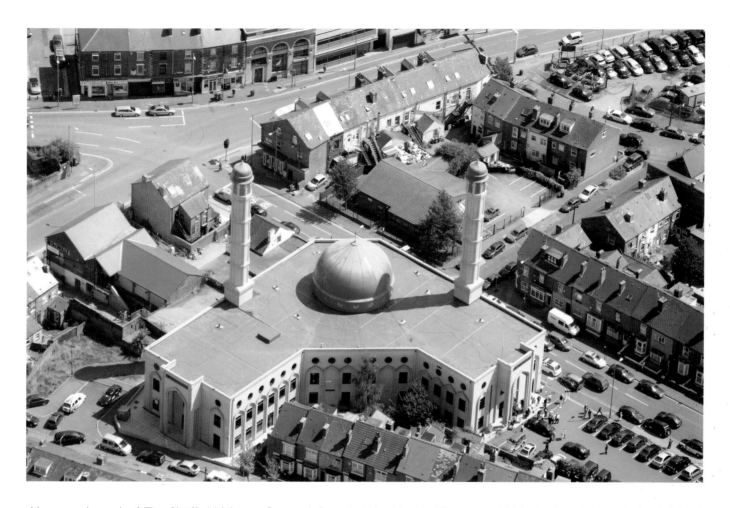

Above and overleaf: The **Sheffield Islamic Centre** is based at the Madina Mosque on Wolseley Road. It is a design inspired by the Prophet Muhammed mosque in Madina, Saudi Arabia. It is the first purpose-built mosque in the city and was completed in 2006 at a cost of approx £5 million.

Opposite: Seen here on either side of Highfield Place are **Highfield Trinity Church** and **St Barnabas Church**, which is now used as a sheltered complex. Built over a hundred years ago, Highfield Trinity Church was founded in the Methodist tradition.

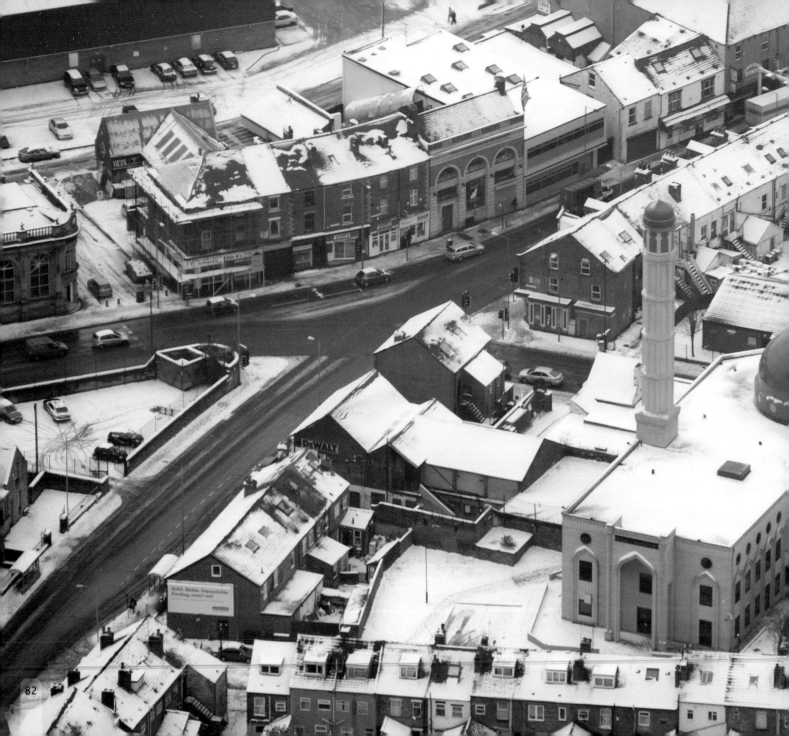

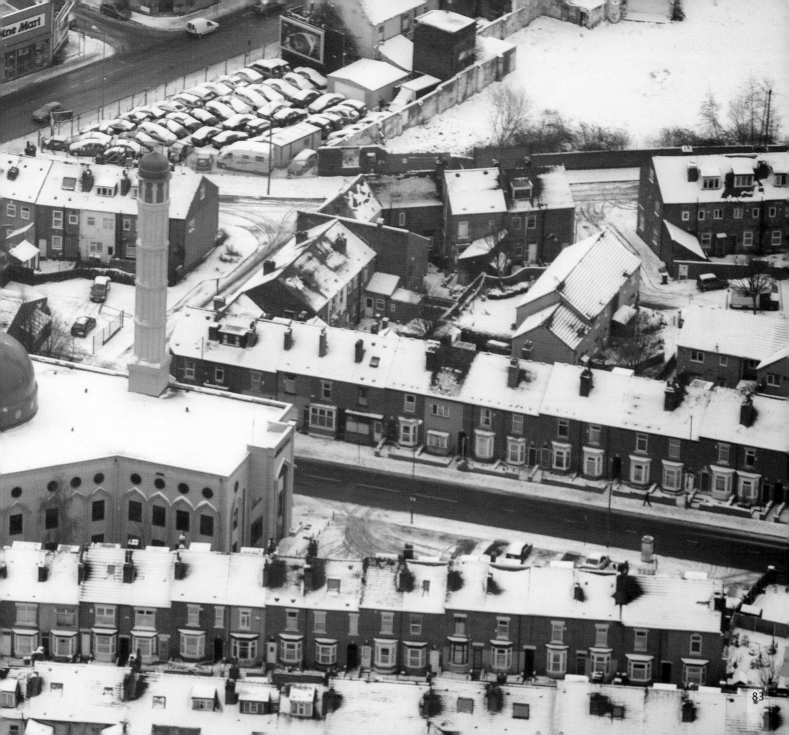

83

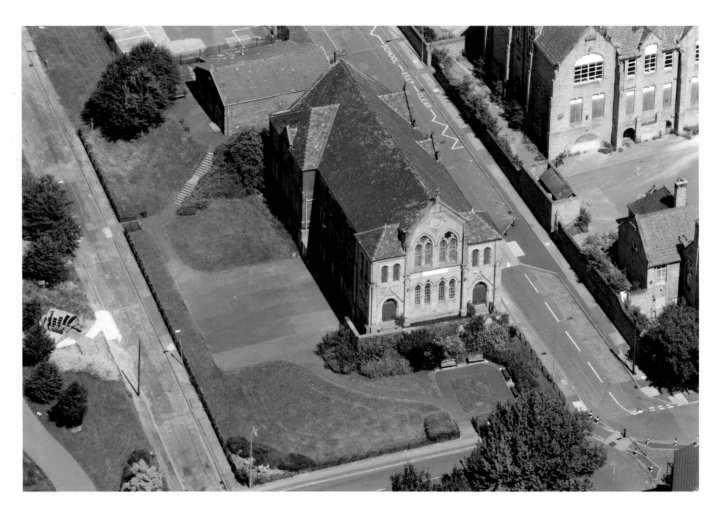

Above: Adjacent to the Heeley Millennium Park is the Chinese Christian Church.

Opposite: Victoria Hall on Norfolk Street in the heart of the city is a Methodist place of worship. The foundation stone for the current hall was laid in 1906 on the site of the former Norfolk Street Wesleyan Chapel.

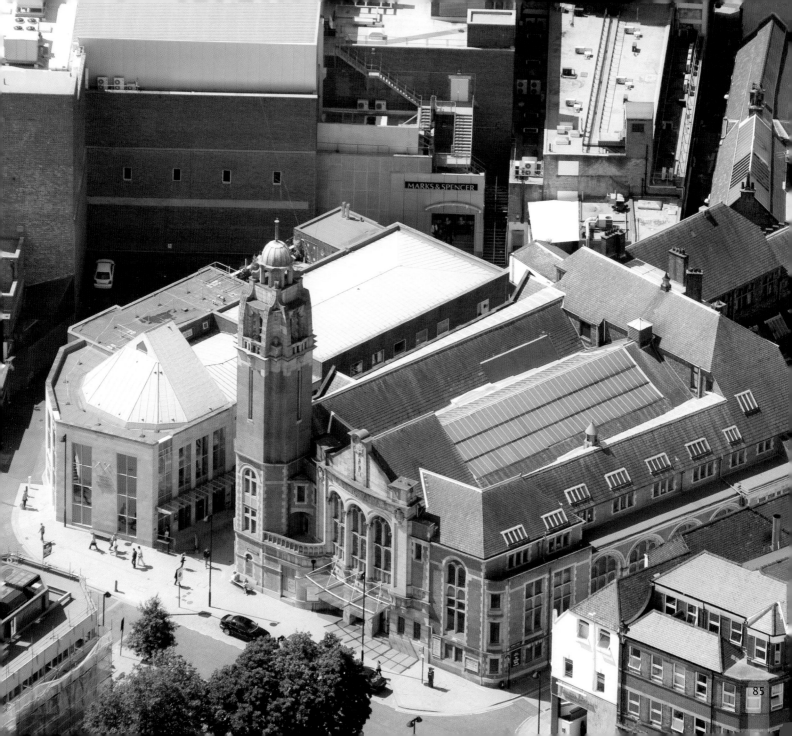

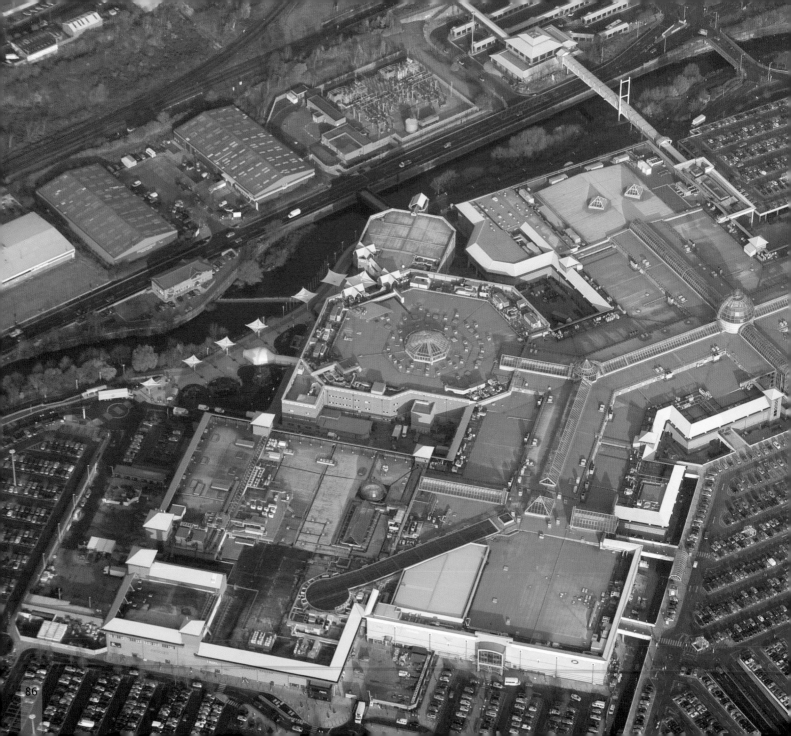

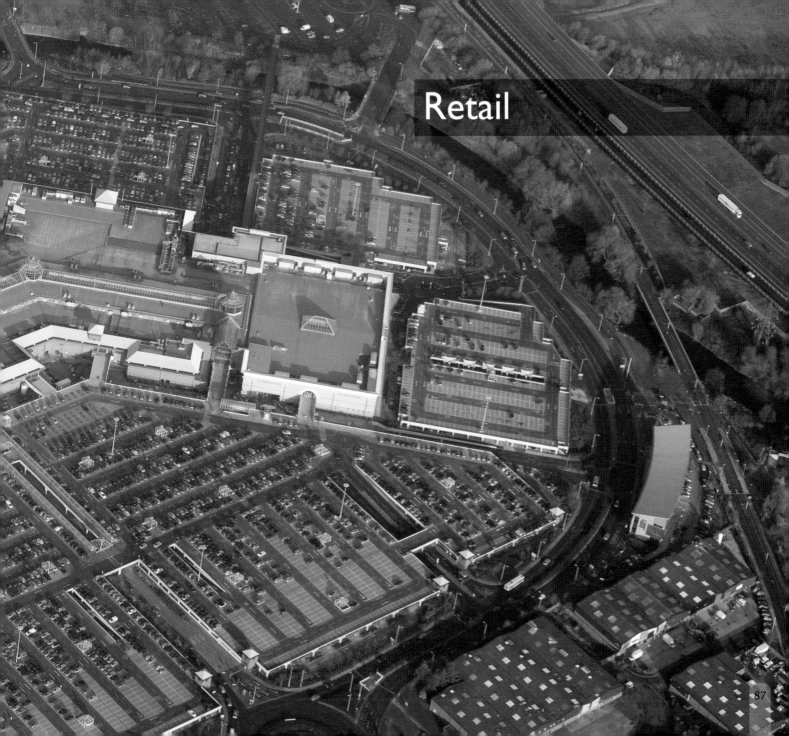

Retail

Previous page and right: When it was opened in 1990 the **Meadowhall shopping centre** was the sixth largest shopping centre in the UK, with a floor area of approx 140,000 square metres. It stands on the site of a former steelworks alongside the River Don and close to the M1 motorway.

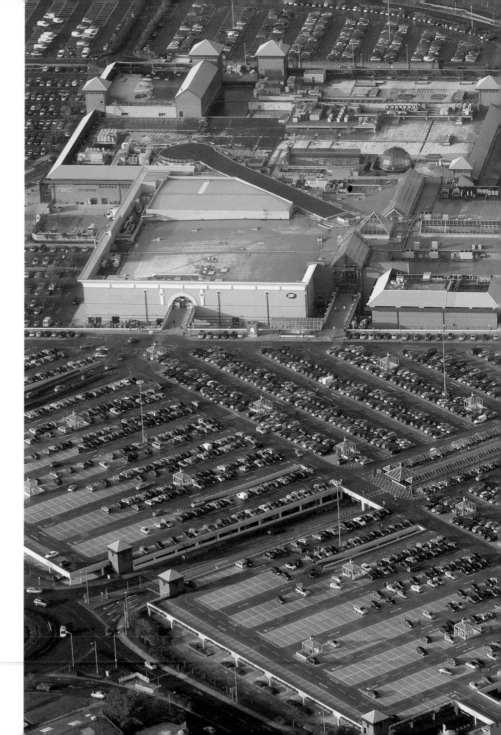

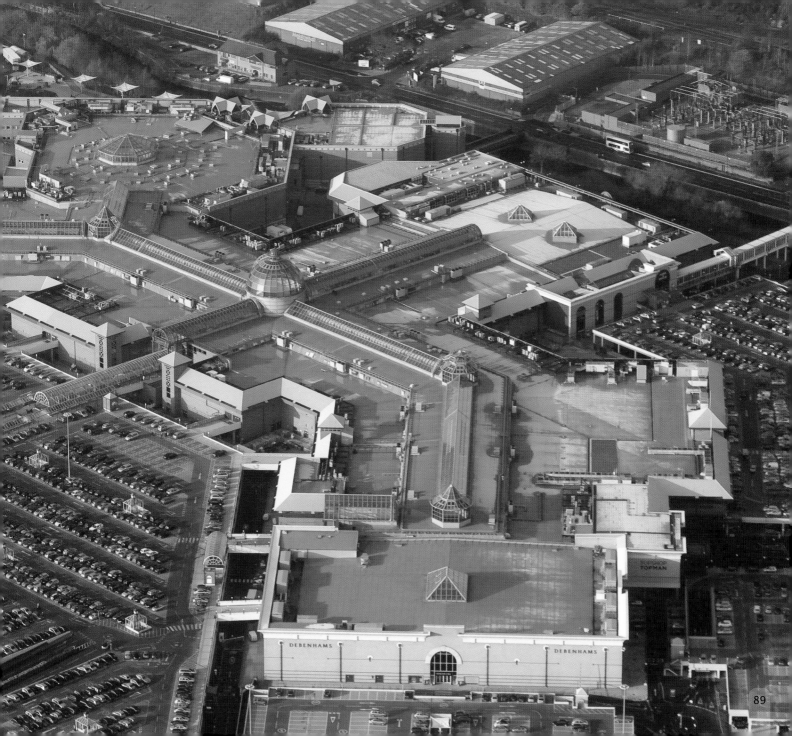

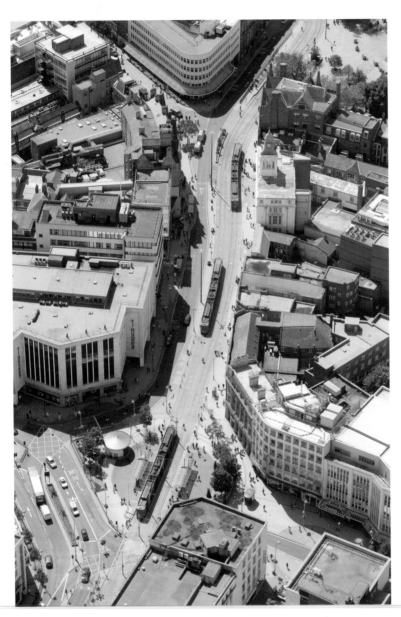

Left: Castle Square is the heart of Sheffield's retail area and stands at the junction of High Street and Arundel Gate. It gets its name from its proximity to the former site of Sheffield Castle.

Opposite: Seen here on the High Street is **Telegraph House**, with its distinctive white stone façade and clock tower.

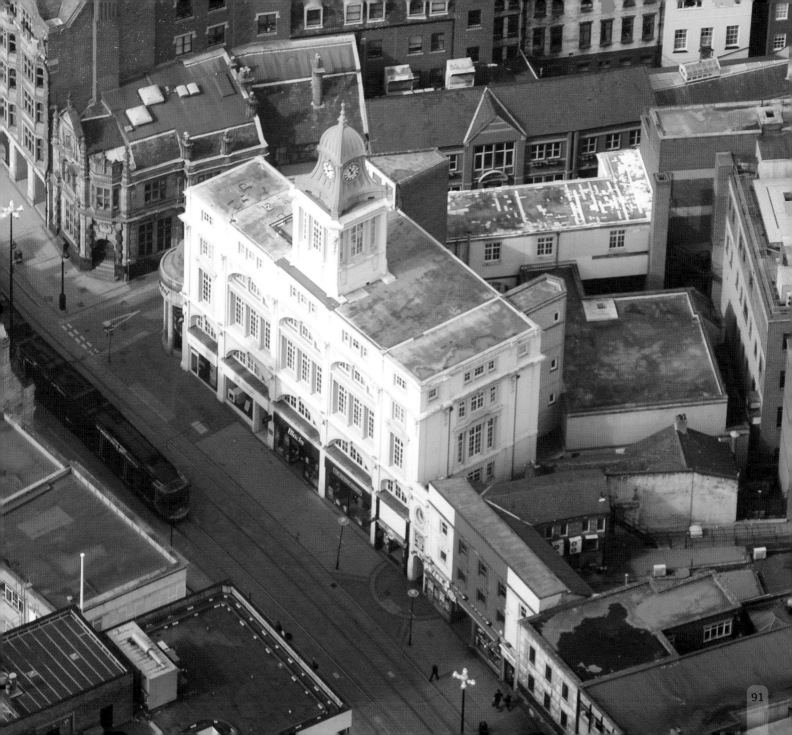

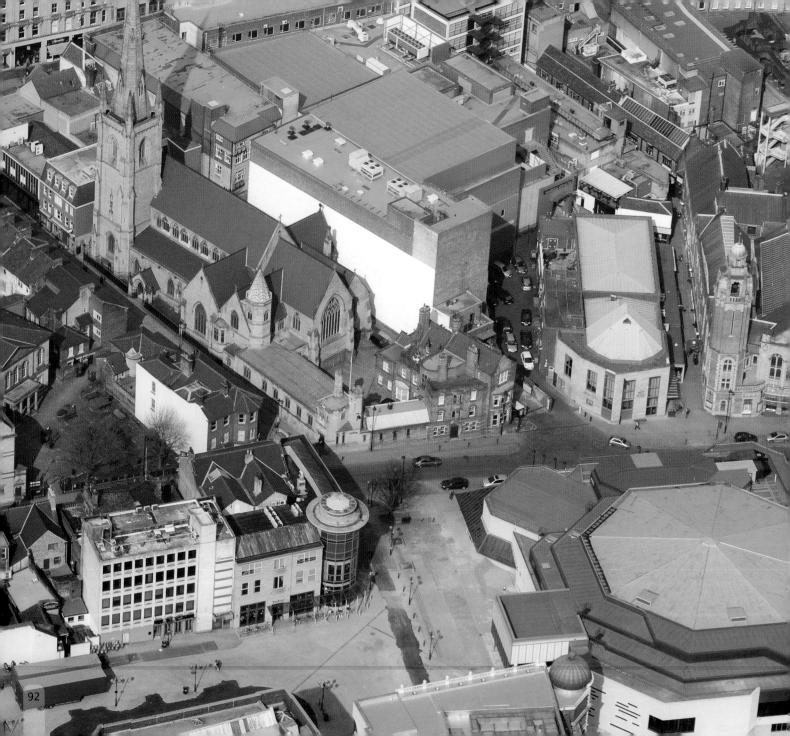

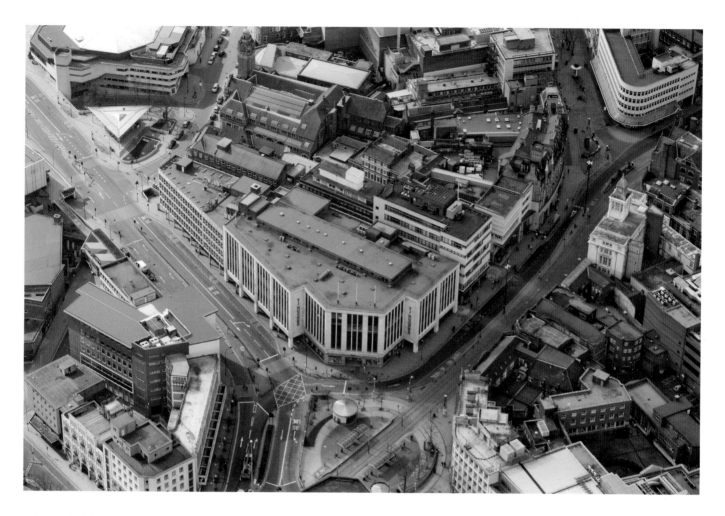

Above: TJ Hughes' department store on High Street.

Opposite: Tudor Square lies to the rear of the Central Library and Lyceum Theatre.

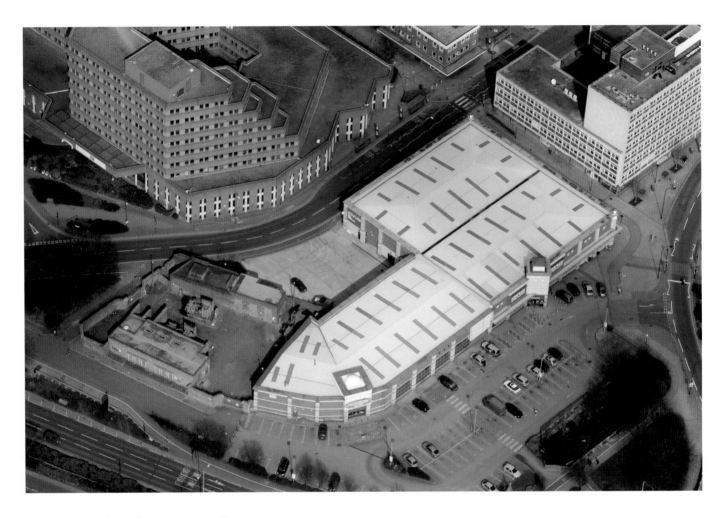

Above: A small retail park off Eyre Street.

Opposite: Ruskins in Tudor Square.

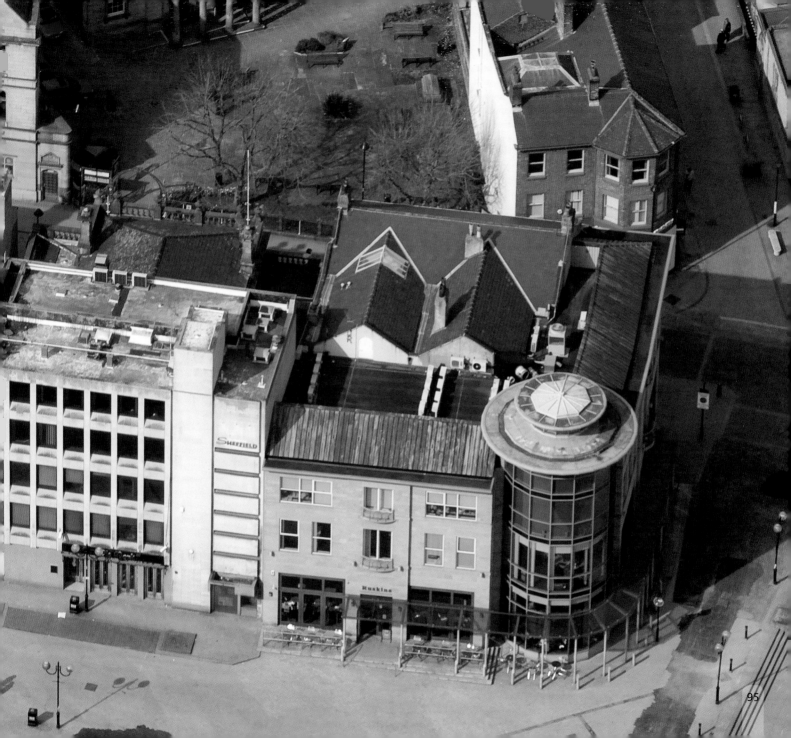

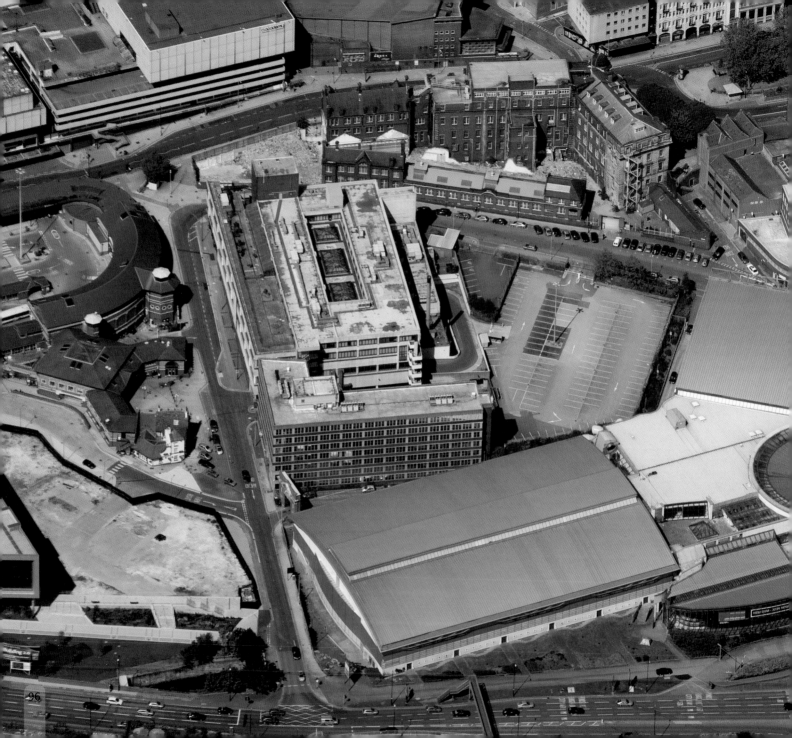

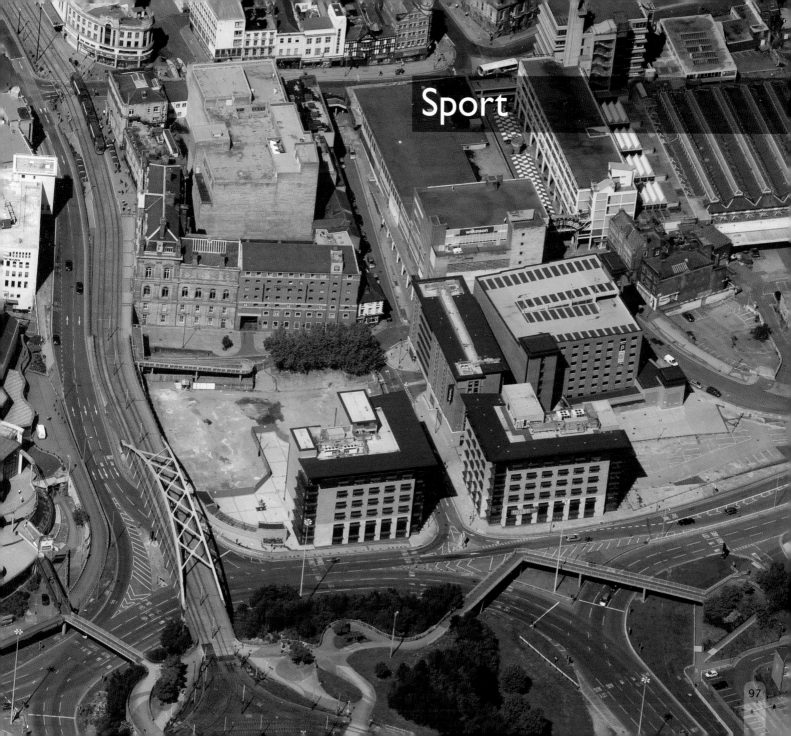

Sport

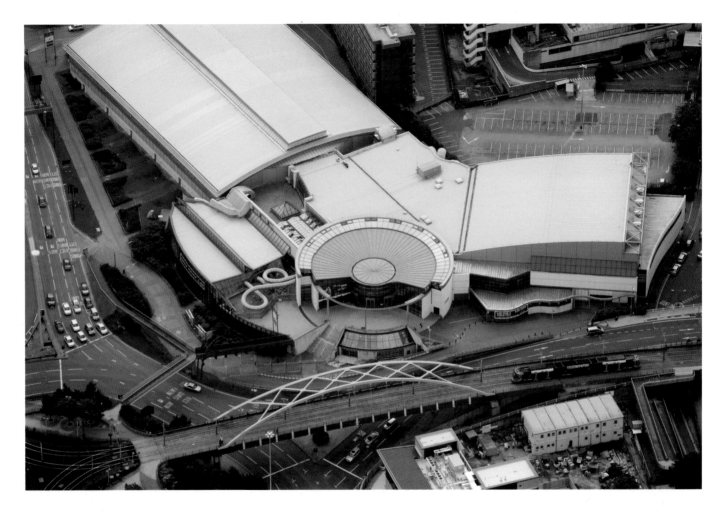

Previous page and above: Opened in 1991 as a venue for the World Student Games is **Ponds Forge International Sports Centre**, which houses an Olympic-sized swimming pool with seating for 2,600 spectators, Europe's deepest diving pool at 5.85 metres, family and children's pools, water slides and other sports facilities. Also within the complex is the International Sports Hall, which is used as a basketball venue and has hosted international matches for the Great Britain team on several occasions.

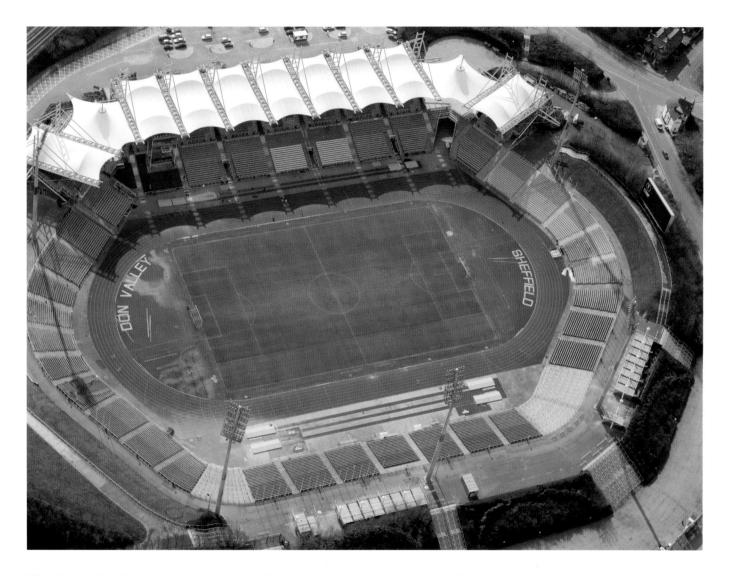

The **Don Valley Stadium** was opened in 1990 ready for the World Student Games the following year. As well as athletics, the stadium is home to Rotherham United Football Club and Sheffield Eagles Rugby League Football Club.

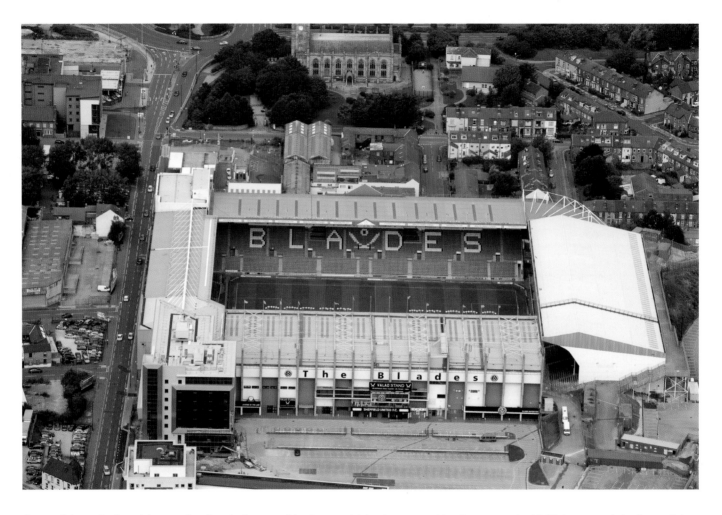

Bramall Lane is the oldest major football ground in the world, having staged its first game in 1862. It was originally a cricket ground and home to Sheffield United Cricket Club. In 1889 Sheffield United Football Club was also formed as a way of keeping the cricket team together during the winter.

Yorkshire County Cricket Club also played here until 1973. In 1975 the final cricket match was played at the ground and it has since expanded to the all-seater stadium of today, with over 32,000 seats.

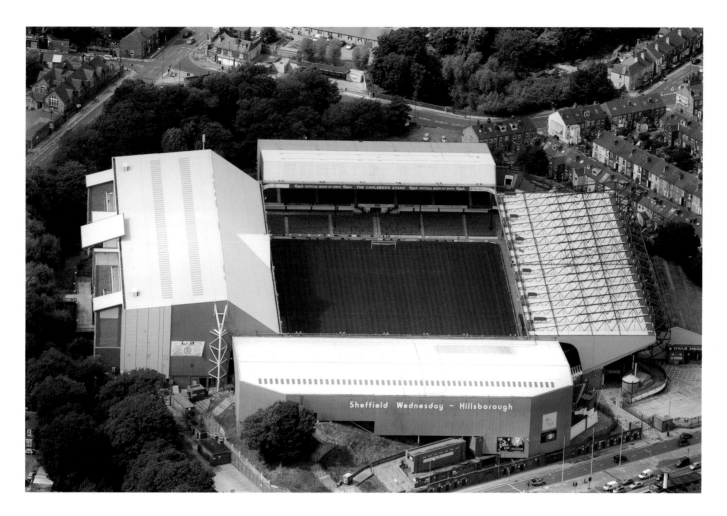

Hillsborough Stadium was originally built in 1899 and has grown over the years to become the 39,000-seat stadium it is today. It is home to Sheffield Wednesday Football Club, who took their name from a cricket club that played matches on Wednesdays. The football club was formed in 1867 as a way of keeping the cricket team together and fit during the winter.

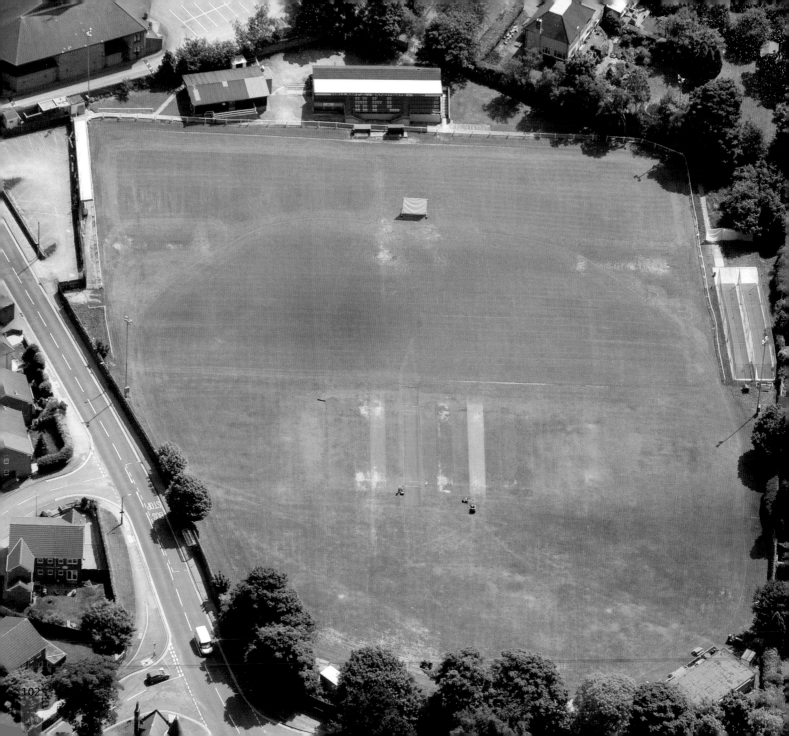

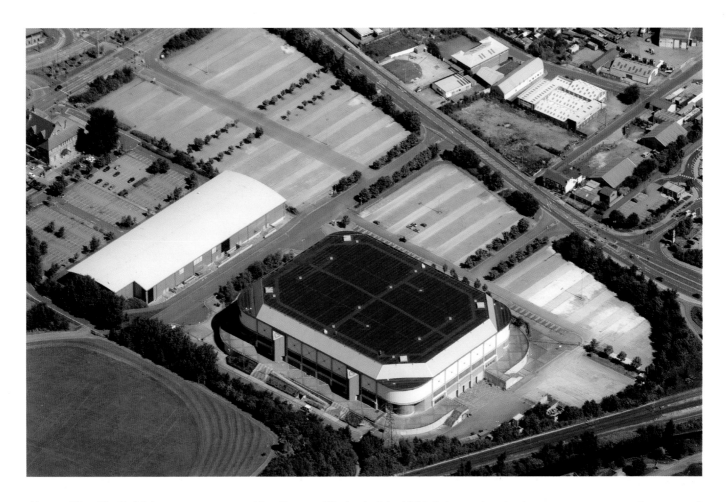

Above: The **Sheffield Arena** was opened by Queen Elizabeth II in 1991. It is used as both a sports venue and as one of Yorkshire's premier concert venues. As a sports venue it has been used for such diverse sports as ice hockey, basketball and indoor motorcycle trials.

Opposite: Even older than Bramall Lane is **Sandygate Road**. Opened in 1804, it has been recognised by the *Guinness Book of Records* as the 'Oldest Ground in the World'. The ground is home to Hallam Football Club and Hallam Cricket Club.

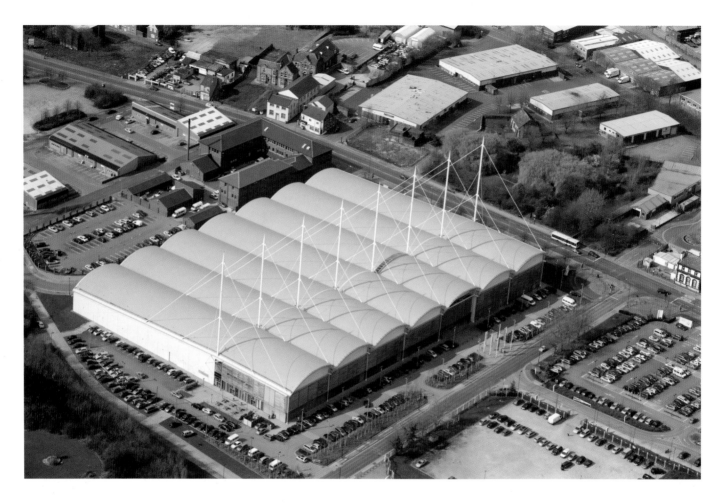

Above: The **English Institute of Sport** was opened in 2003 and has been hailed as one of the country's leading indoor sports facilities. There is a 200m banked oval running track, an Olympic-sized boxing ring, throwing and jumping areas, badminton courts and martial arts training areas.

Opposite: Situated between the English Institute of Sport and the Sheffield Arena is an ice arena known as **Ice Sheffield**. The arena can seat 1,500 people around its two Olympic-size ice rinks.

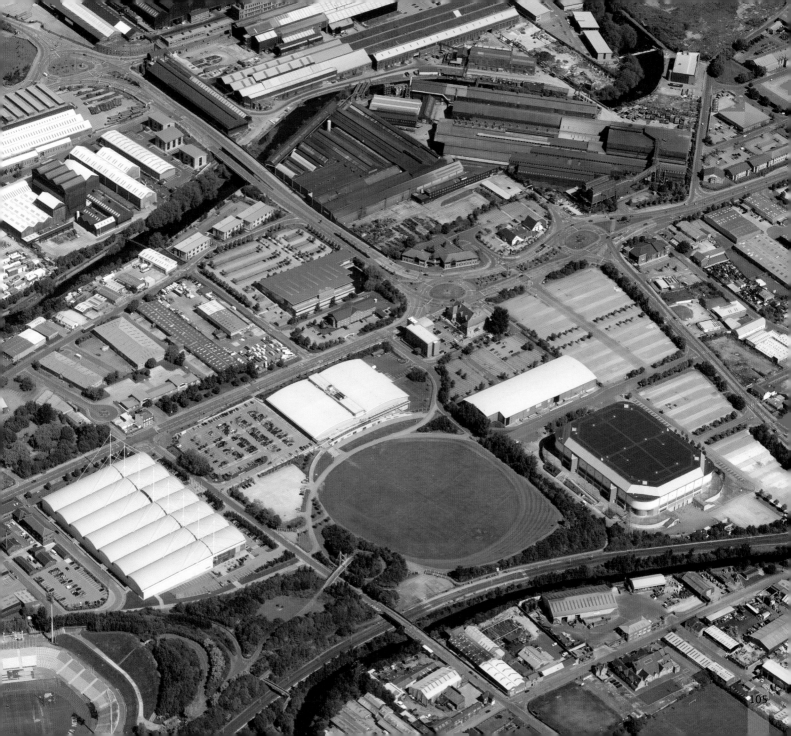

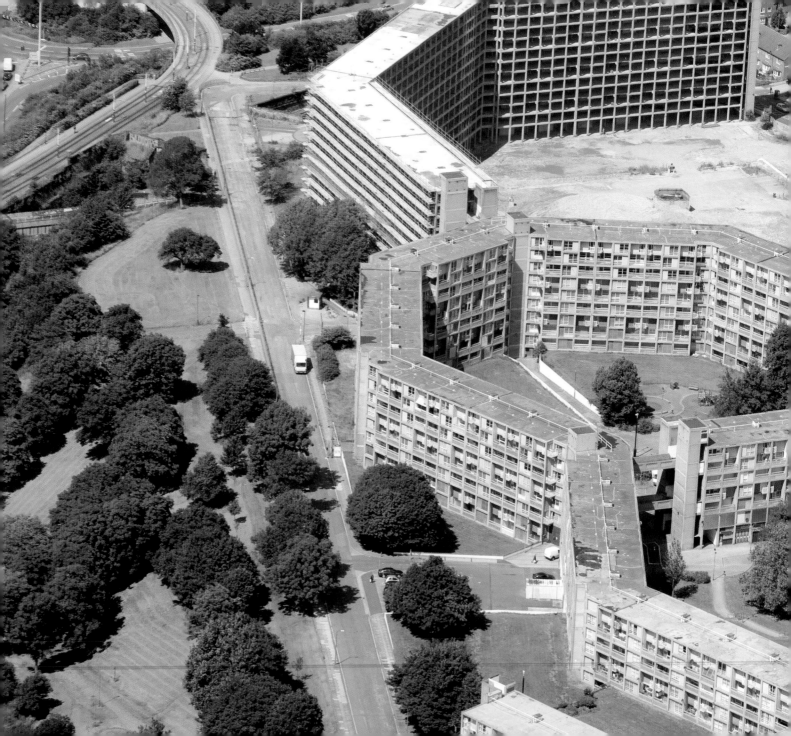

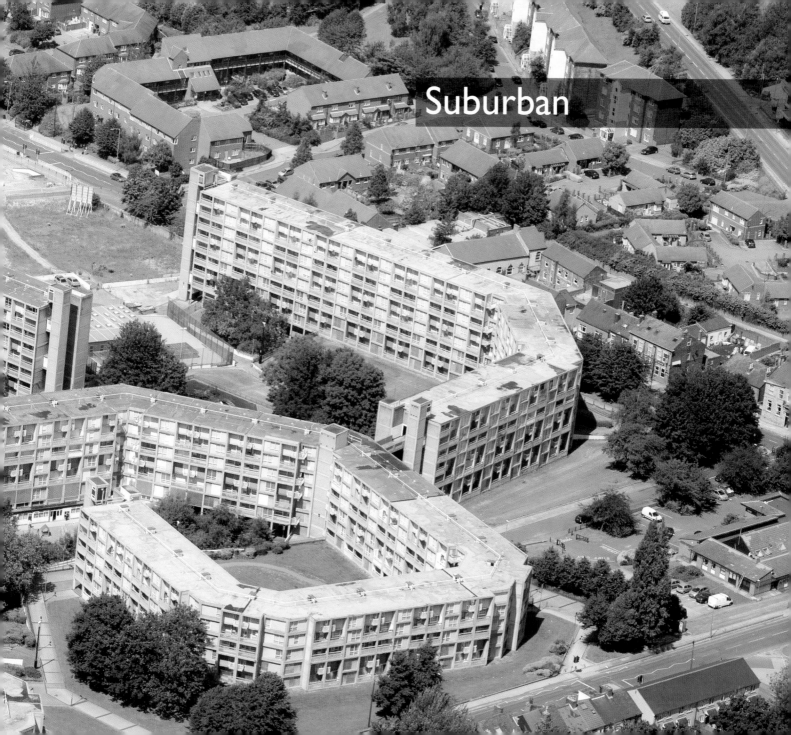

Suburban

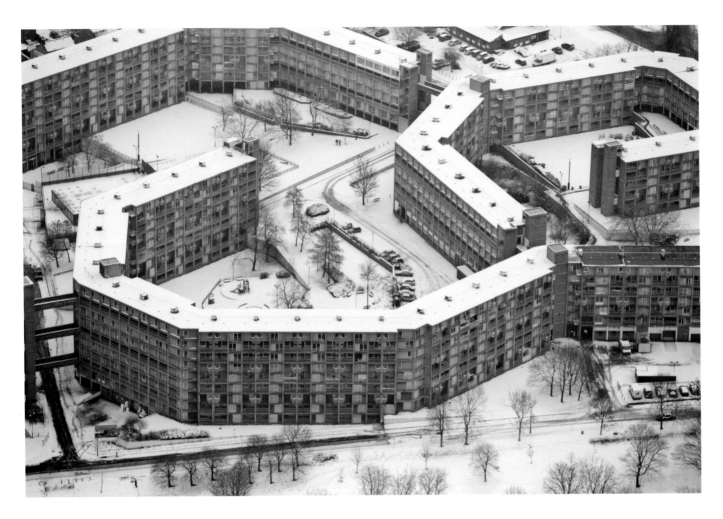

Above and previous page: Designed by Jack Lynn and Ivor Smith and built between 1957 and 1961, **Park Hill** council housing estate became a Grade II-listed building in 1998, making it the largest listed building in Europe.

Opposite: Seen here with a covering of snow is the traditional terrace housing of **Popple Street** and (overleaf) **Southview Road**.

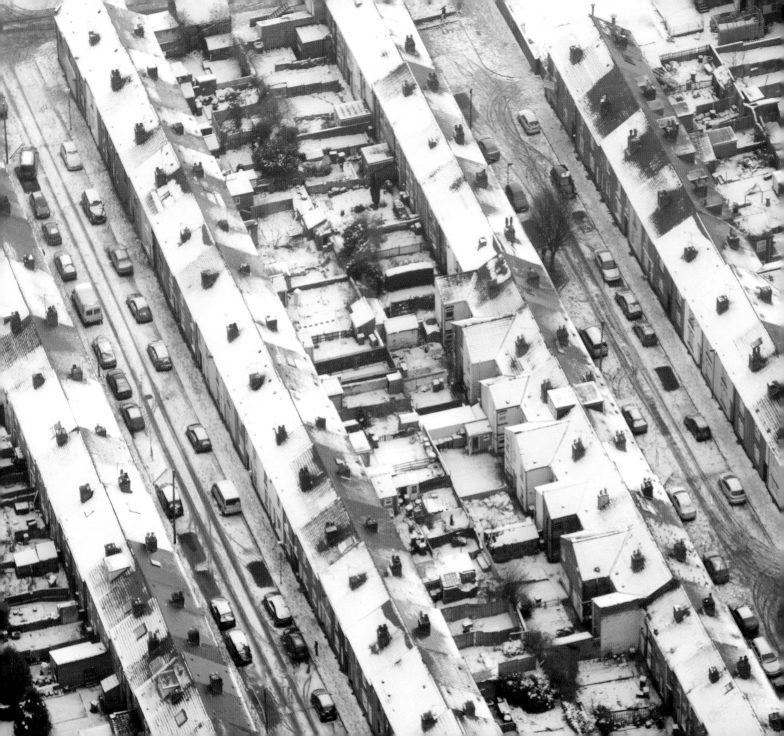

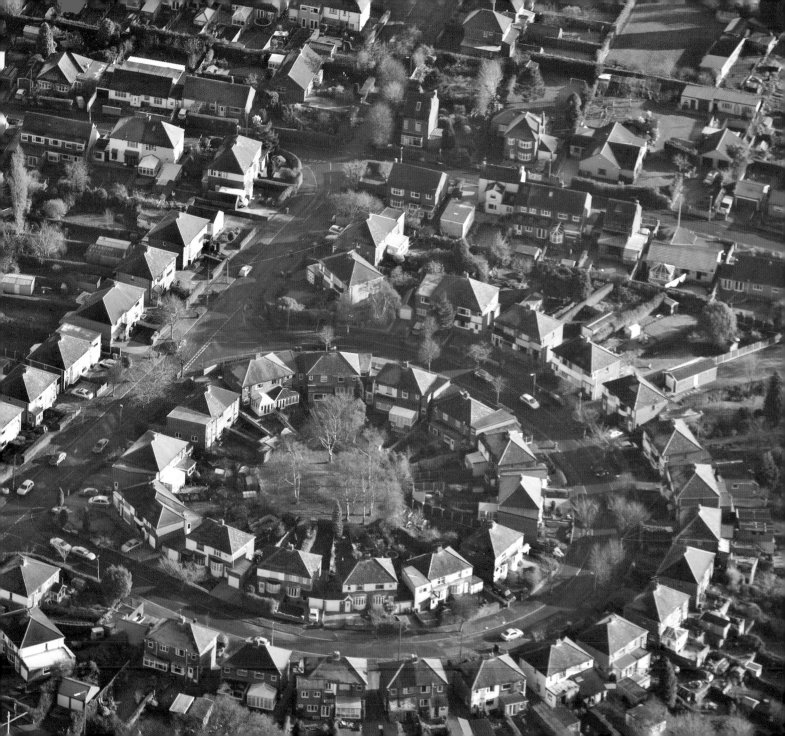

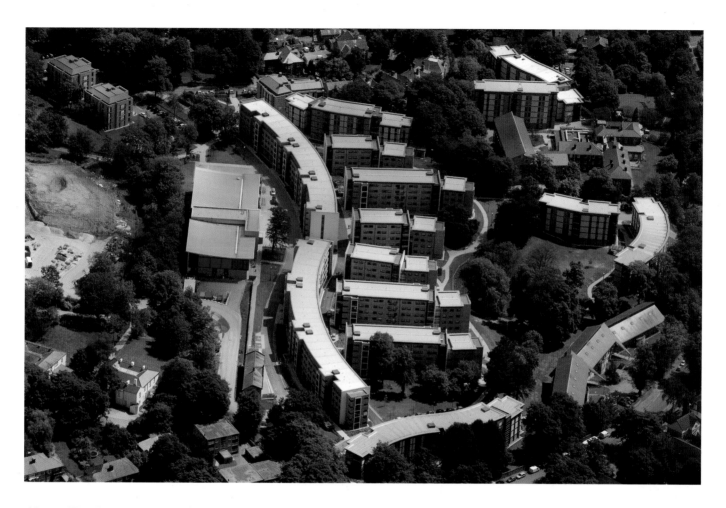

Above: The **Endcliffe Student Village** is a large development around 3km west of the city centre. It provides accomodation for some of the 40,000 students living in Sheffield. All of the apartment blocks are named after climbing crags in the nearby Peak District.

Opposite: Rather than the straight lines of terrace houses, here on **Briarfield Crescent** the planners adopted a more 'roundabout' approach.

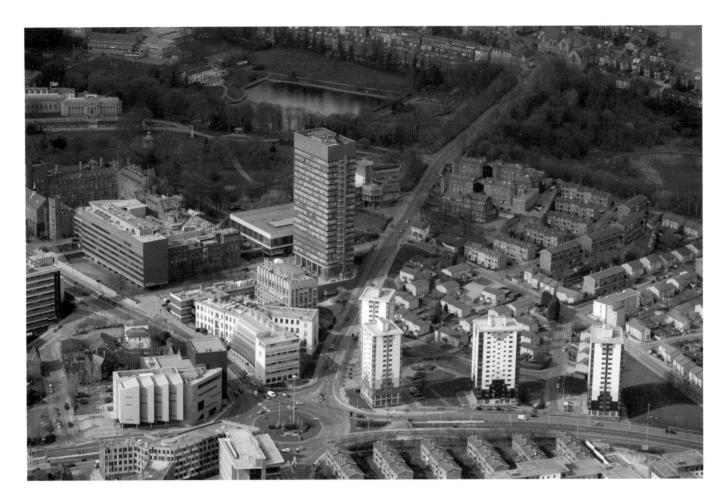

Above: To the west of the city in the **Netherthorpe** area are these colourful high-rise flats. To the left of the flats on Netherthorpe Road can be seen many of the University of Sheffield buildings, and to the top left of the photo is Weston Park.

Opposite: The six tower blocks on **Callow Place** are typical 1960s high-rise accommodation blocks. What makes them unusual is the fact that they now have heat and hot water provided by a biomass boiler, which uses wood chips for fuel.

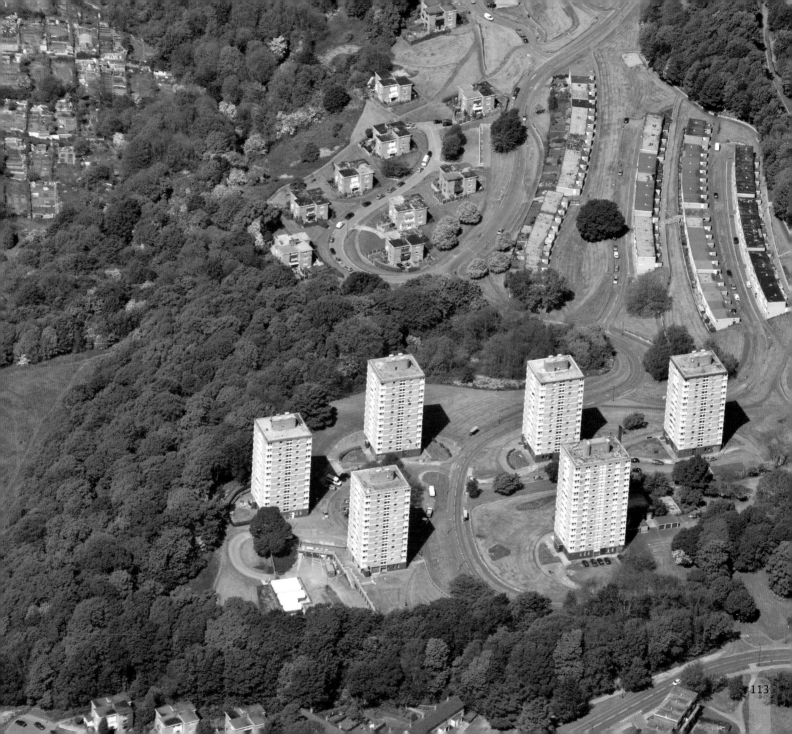

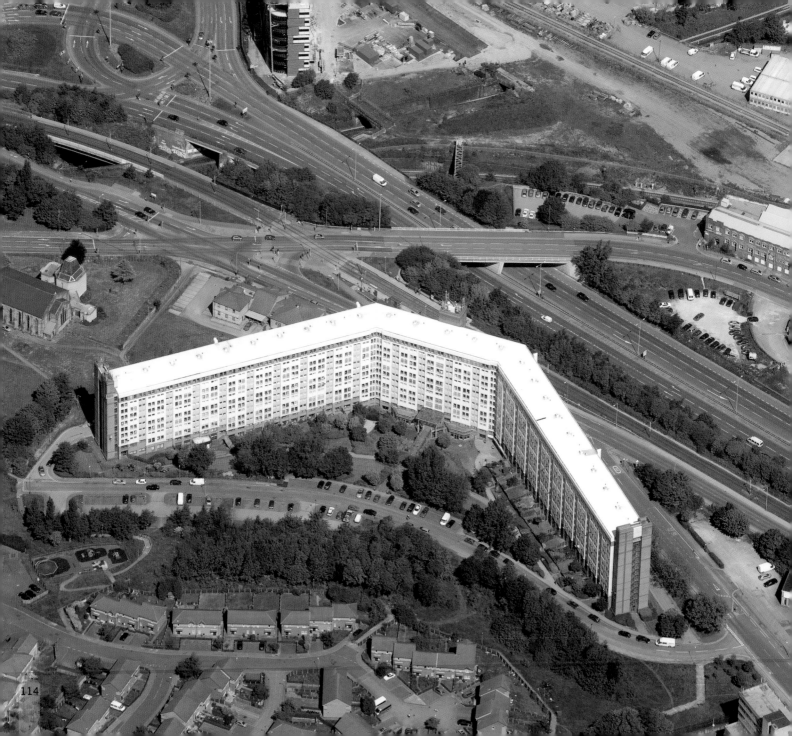

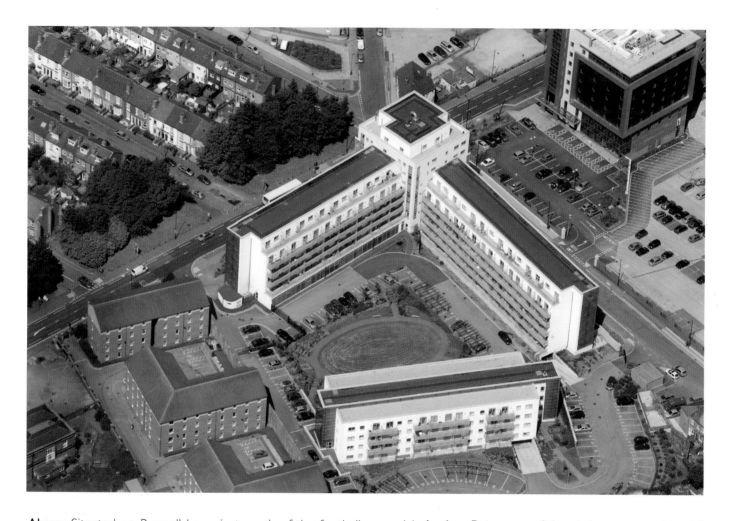

Above: Situated on Bramall Lane, just south of the football ground, is **Anchor Point**, one of the city's newest residential apartment blocks.

Opposite: Castle Court flats on St John's Road were built to house competitors in the 1991 World Student Games. The complex houses 240 apartments over its 10 floors.

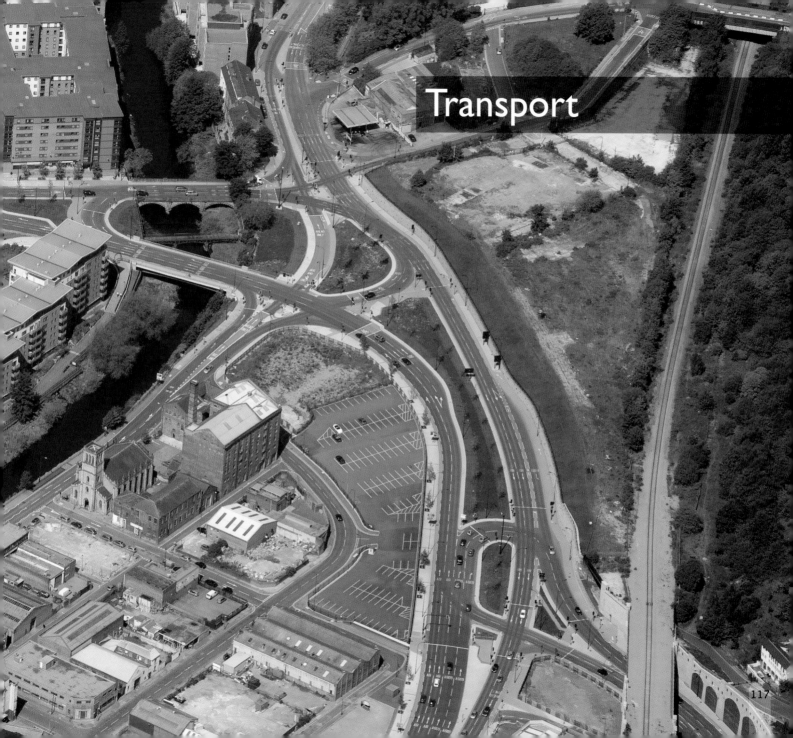

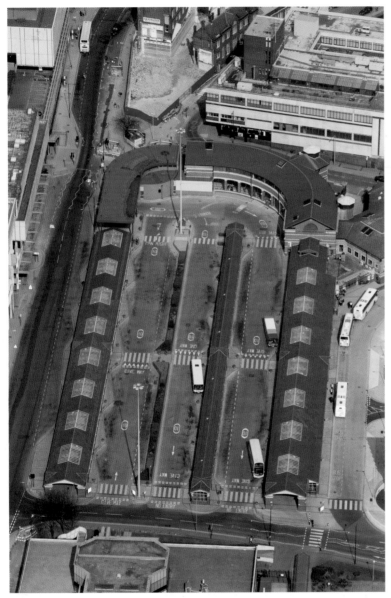

Left: Situated close to the city centre is the main bus station known as the **Sheffield Interchange**.

Opposite: Lying close to the M1 motorway, to the north-east of the city, is the **Meadowhall Interchange**. The Interchange serves the Meadowhall shopping centre with a Midland Mainline railway station, bus station and Supertram station.

There is a covered walkway from the Interchange which carries pedestrians over the River Don directly into the shopping centre.

Previous page: Rail, river and roads.

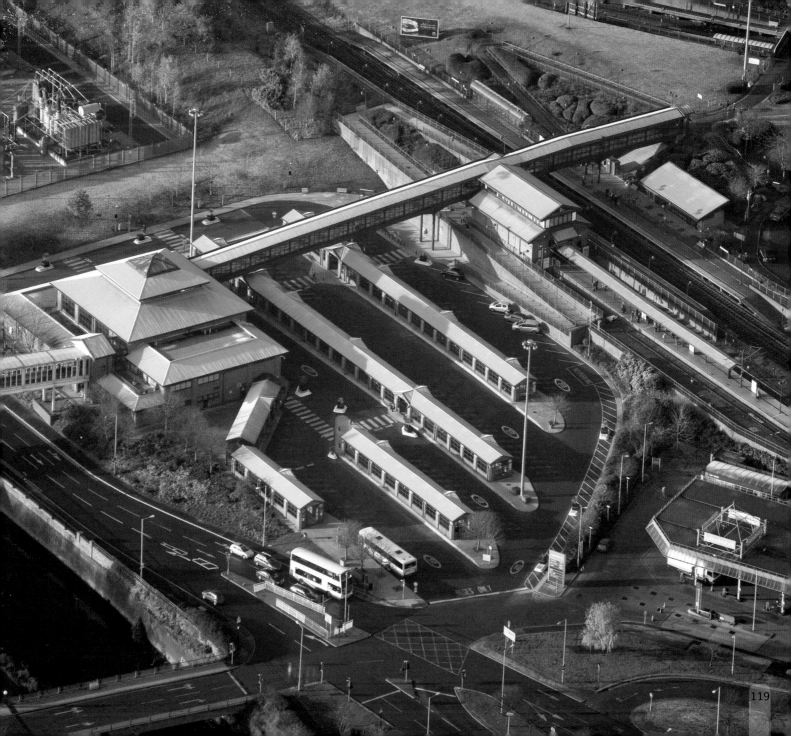

119

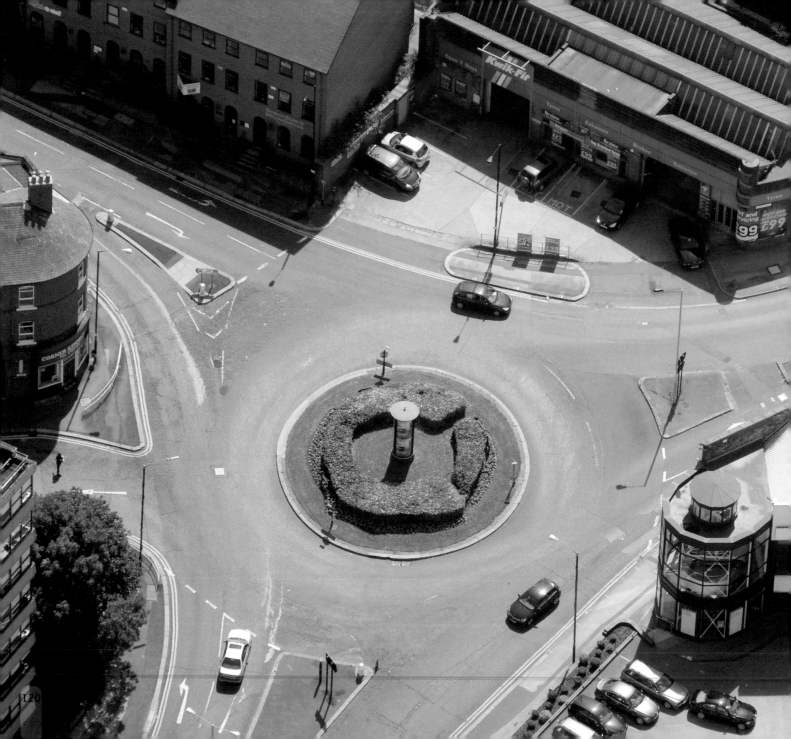

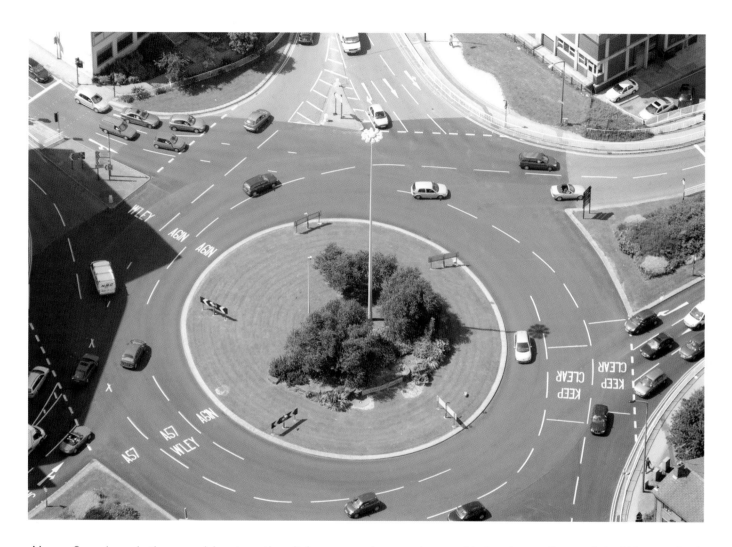

Above: Seen here is the roundabout on the city's **western bypass** close to Netherthorpe flats and the Western Bank campus buildings of Sheffield University.

Opposite: An attractively planted roundabout at the junctions of Broad Lane, Townhead Street and Tenter Street.

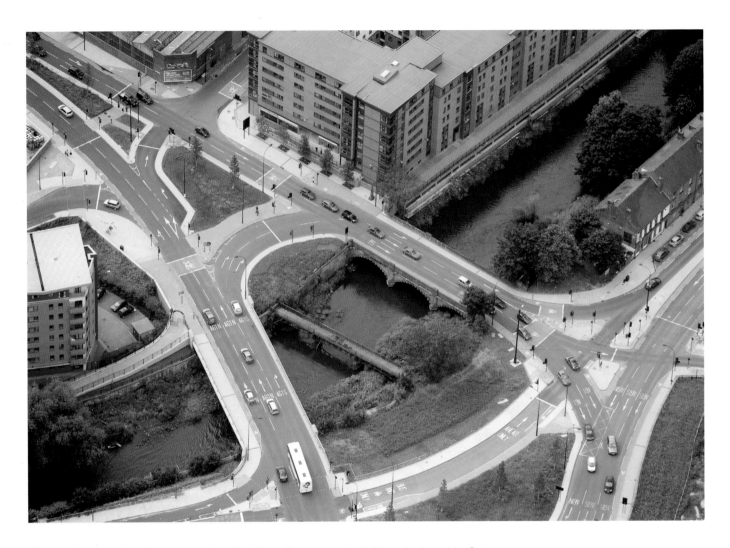

Above: Corporation Street crossing the River Don near the Millsands riverside flats.

Opposite: Looking along the River Don from the Millsands riverside flats at the bottom of the picture to Hillsborough Stadium at the top.

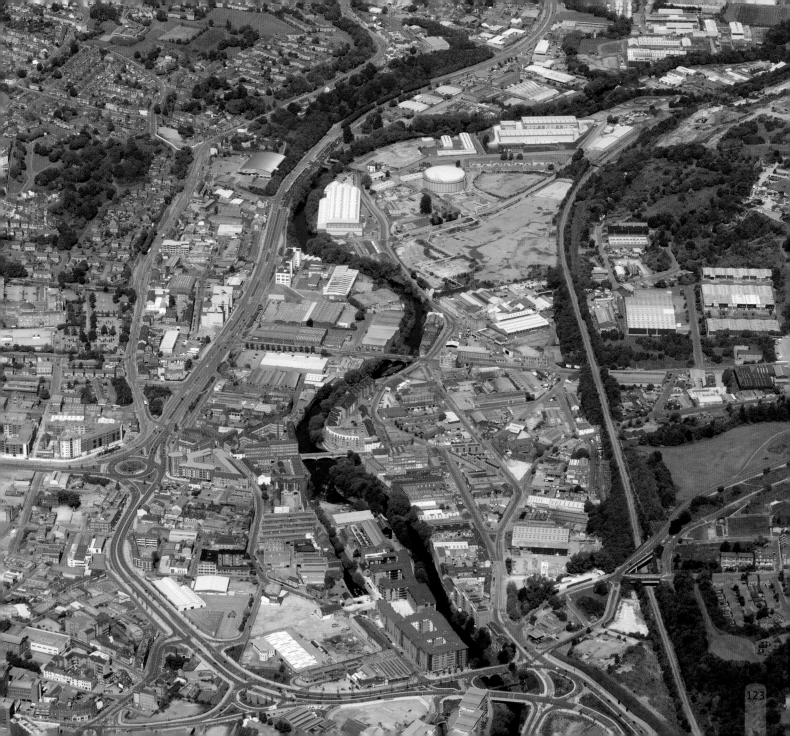

Above and right: Sheffield city airport was opened in 1997 and closed to all aircraft except the police and air ambulance helicopters in 2008.

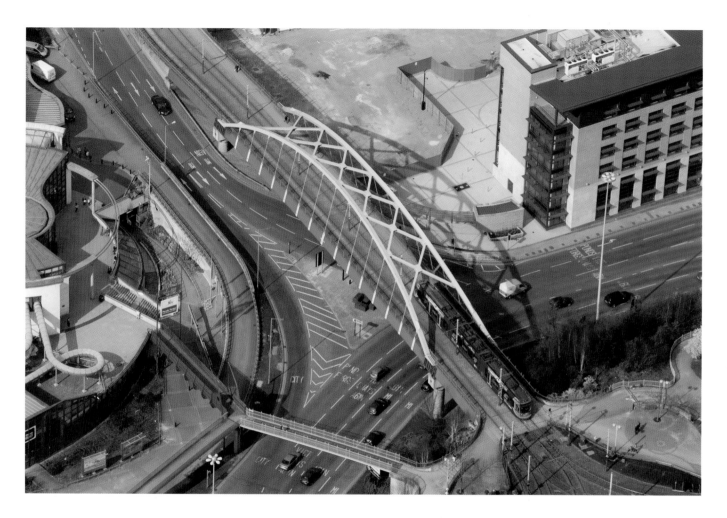

Above: Sheffield's original trams were scrapped in 1960, but by the 1980s it was decided that the city's needs would best be met by a new tram system. Work on the 'Supertram' was started in 1990 and completed in 1995. Today it carries over 15 million passengers a year on its 29km network.

Opposite: Castle Square tram stop.

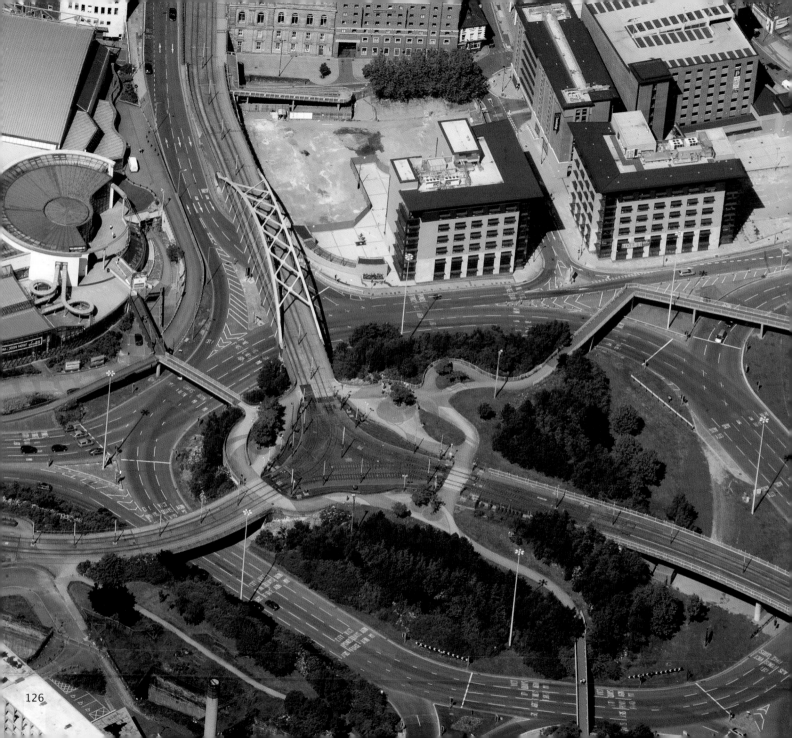

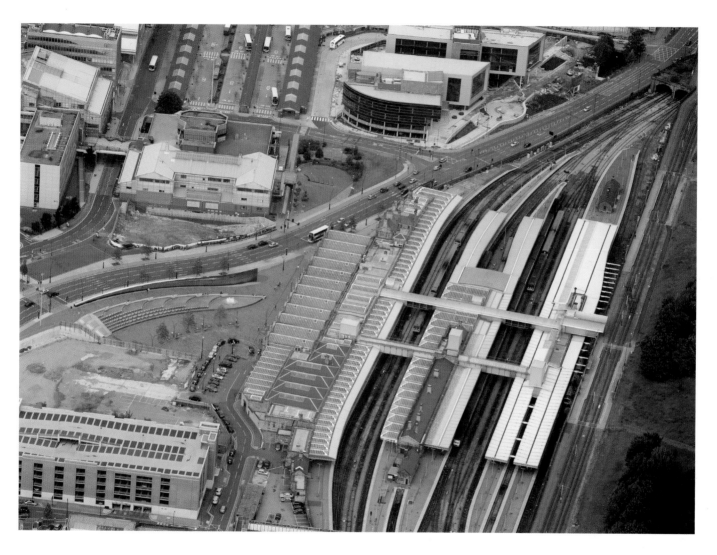

Above, overleaf and final page: Sheffield Railway Station is owned by Network Rail.

Opposite: The Supertram network design team very cleverly utilised space over the top of Park Square roundabout.

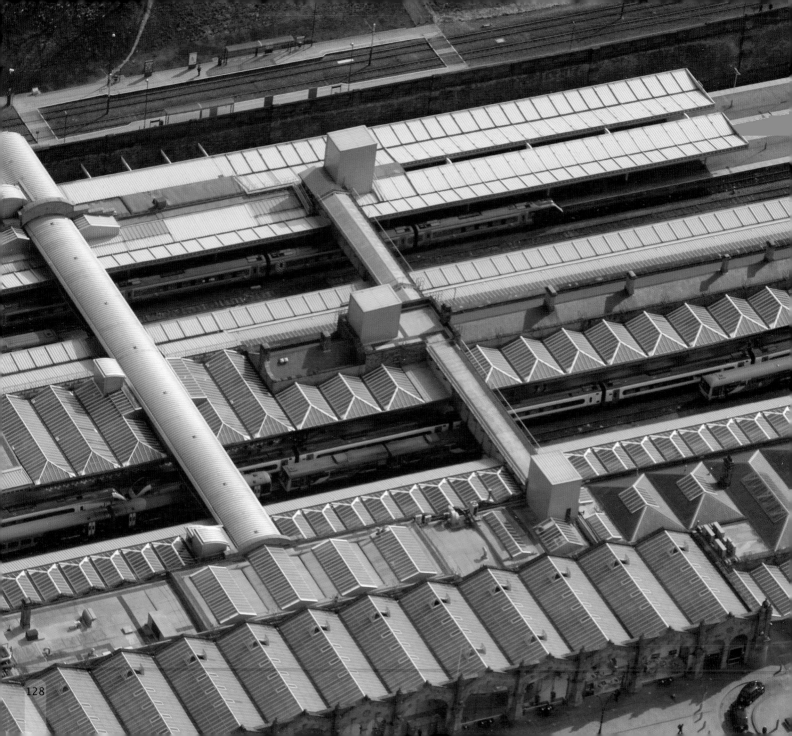